# THE UNOFFICAL
# EMILY IN PARIS
# COLORING BOOK

# THE UNOFFICAL
# EMILY IN PARIS
# COLORING BOOK

COLOR OVER 50 IMAGES
OF CHARACTERS,
PARISIAN FASHION,
AND MORE!

ILLUSTRATED BY
ANA KAREN PÉREZ VELASCO

EPIC INK

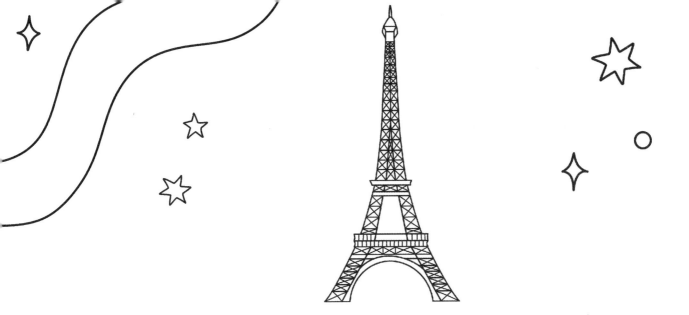

# A Little 'Bonjour' Goes a Long Way

Ooo la la, Paris! Who would turn down a free trip to the city of love? Where the French don't start work until 10am, the people know how to cook, and the city is beautiful and cobblestoned? Yet, in the digital age, there are a few things the French could improve on, and Emily Cooper sure does try. Oh, our sweet *la plouc.*

In the hit Netflix show *Emily in Paris*, Emily moves from Chicago to The City of Light to be the American perspective at a luxury French marketing firm. So what if her French is nonexistent? A little social media prowess goes a long way today. That and a passion for all things fashion, pastries, and marketing. With *The Unofficial Emily in Paris Coloring Book,* you can explore your creativity, safely, without Sylvie breathing down your neck, and find inspiration in the black and white templates just as Emily does when things almost come crumbling down.

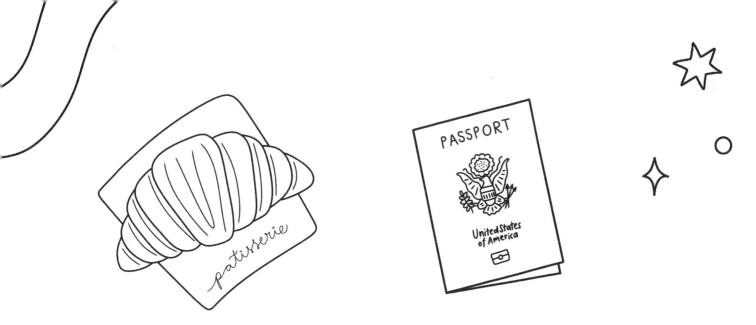

There are no better examples of those leading with instinct and painting the world how they envision it than the characters of this show. Mindy reinvents her life in Paris after a très horrible moment on *Chinese Popstar*; Emily becomes a social media influencer after Savoir reluctantly reactivates her page; and Gabriel works towards opening a country-styled restaurant in the city. Like taking what once was and adding new color to it, even life in Paris can be reimagined. It's a city that's really like a small town, a cute French girl once said. Quaint but full of possibilities. Live life full of self-expression on your terms, and never allow anyone to tell you which colors to use.

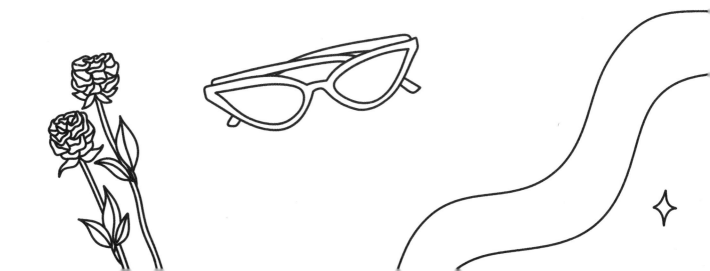

# Like Wearing Poetry

Emily knows we can always count on inspiration to keep us on top. Today, originality at its most authentic is the way to go, as poetic as it sounds. If you're ready to make your mark, start here by coloring in looks of the most fashionable people in Paris and let your artistic mind flow.

Don't be basic, or *ringarde* as Pierre Cadault says. Colors are a way we can remake what has already been. In the world of social media and fashion, trends go in and out of style like a left swipe. Change the perspective. Put your own twist on it, the French way or, even better, *your* way. Express yourself with a marker, colored pencil, watercolor, or whatever type of medium suits you and turn this coloring book into a portfolio worthy of a spot at Paris Fashion Week.

Tackle today's fashion and create full-color scenes from the show you know and love. Use a lot of color, use a little bit. Use your imagination. How would you have done it differently? Go into each piece with the courage to make mistakes and emerge with brand-name results. Take it from our favorite role model Emily Cooper who says yes to new adventures and takes on life with unfiltered passion and enthusiasm. Design, create, inspire! There might even be croissants waiting for you.

*C'est la vie!*

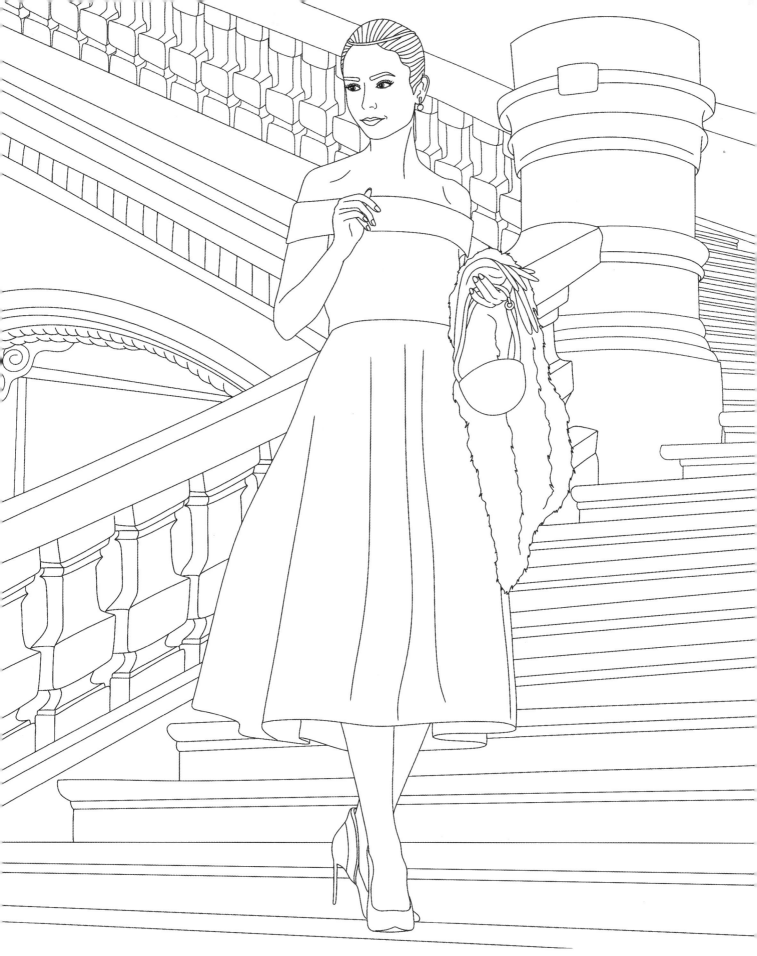

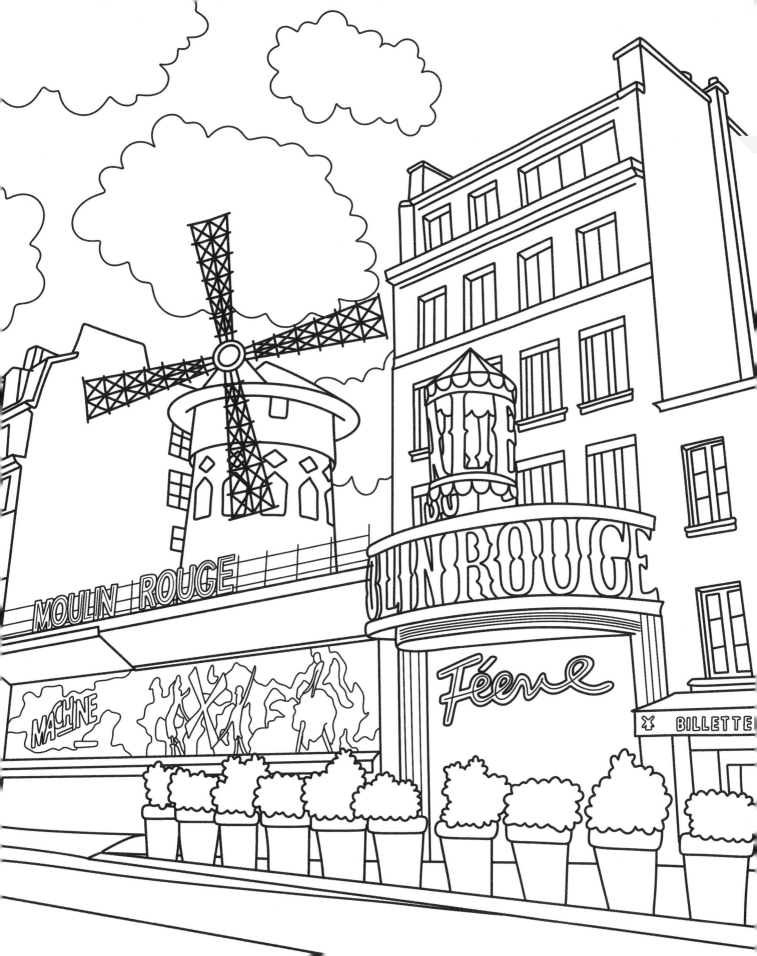

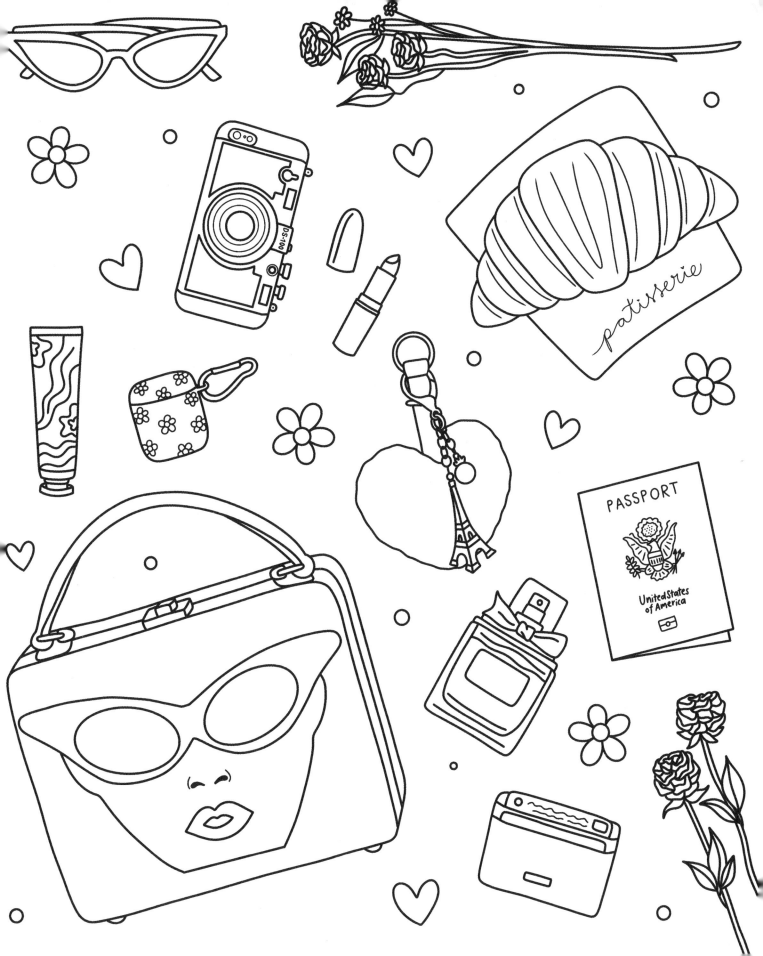

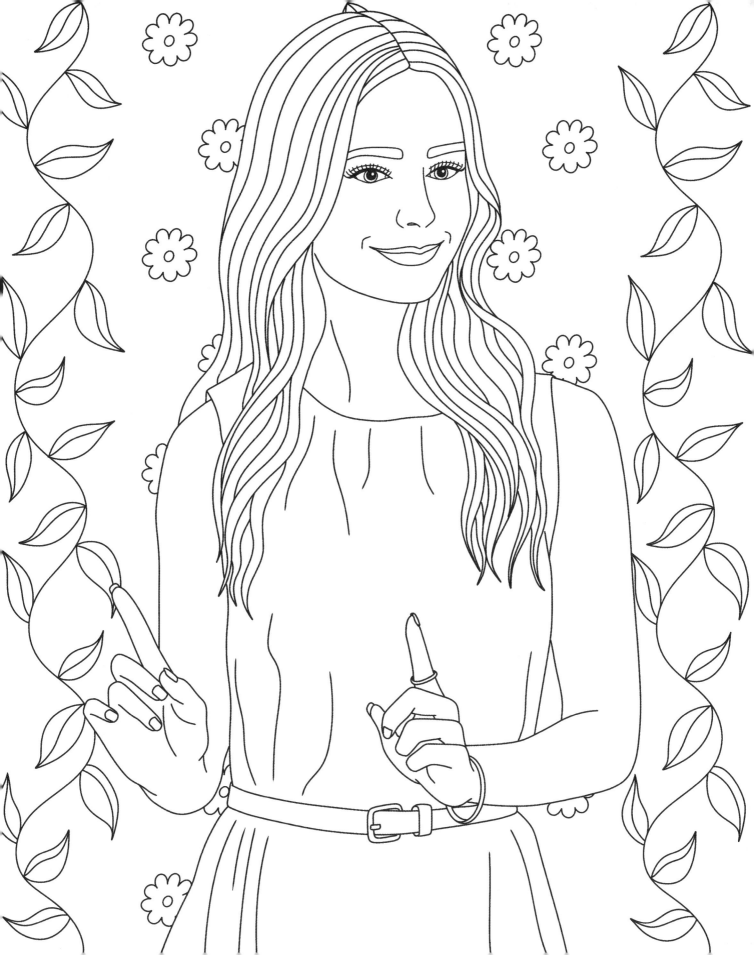

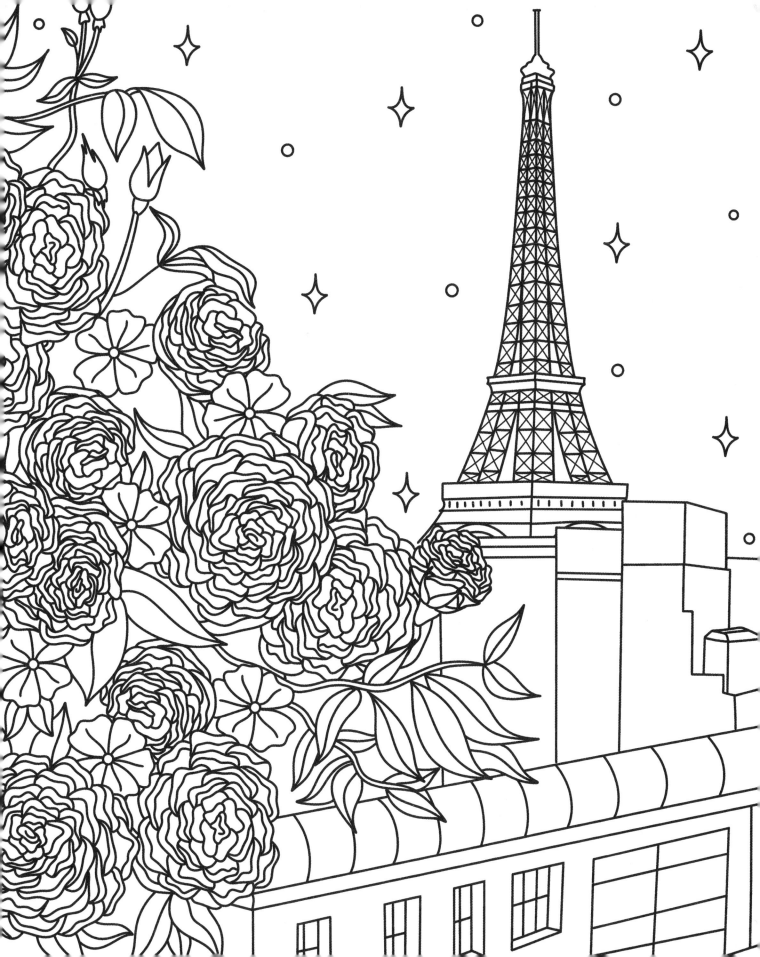

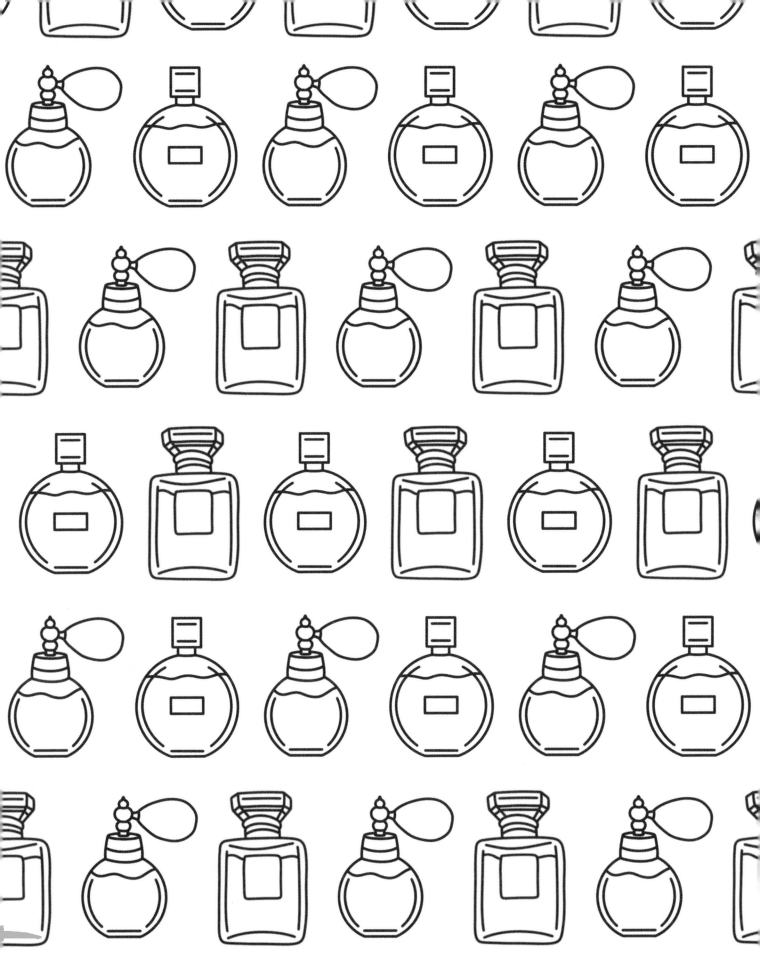

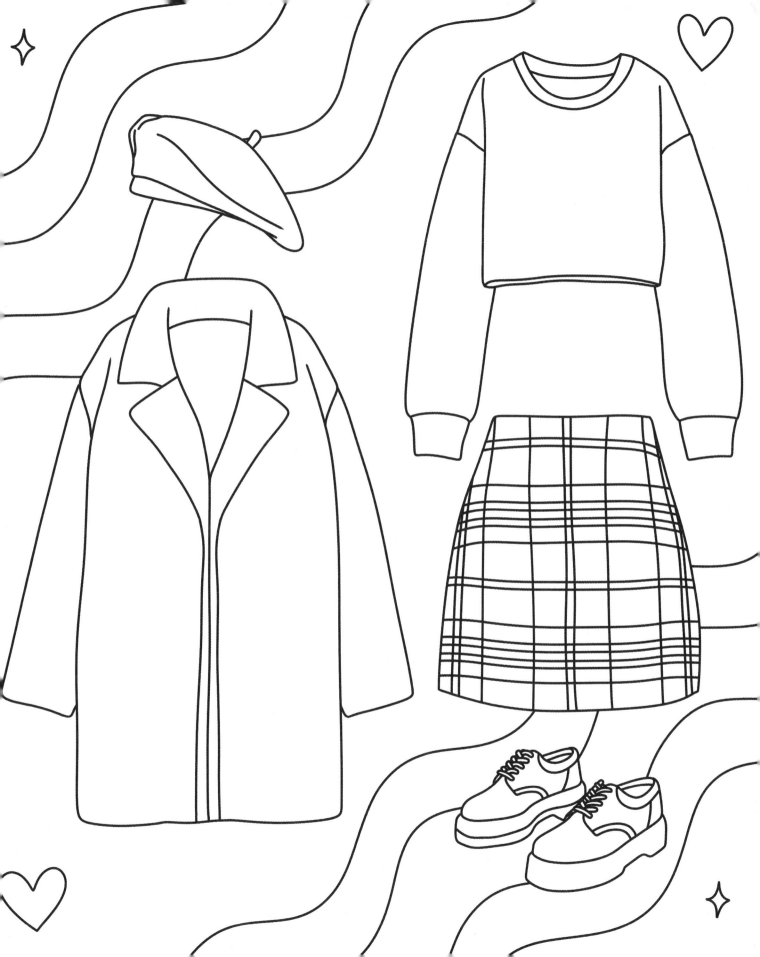

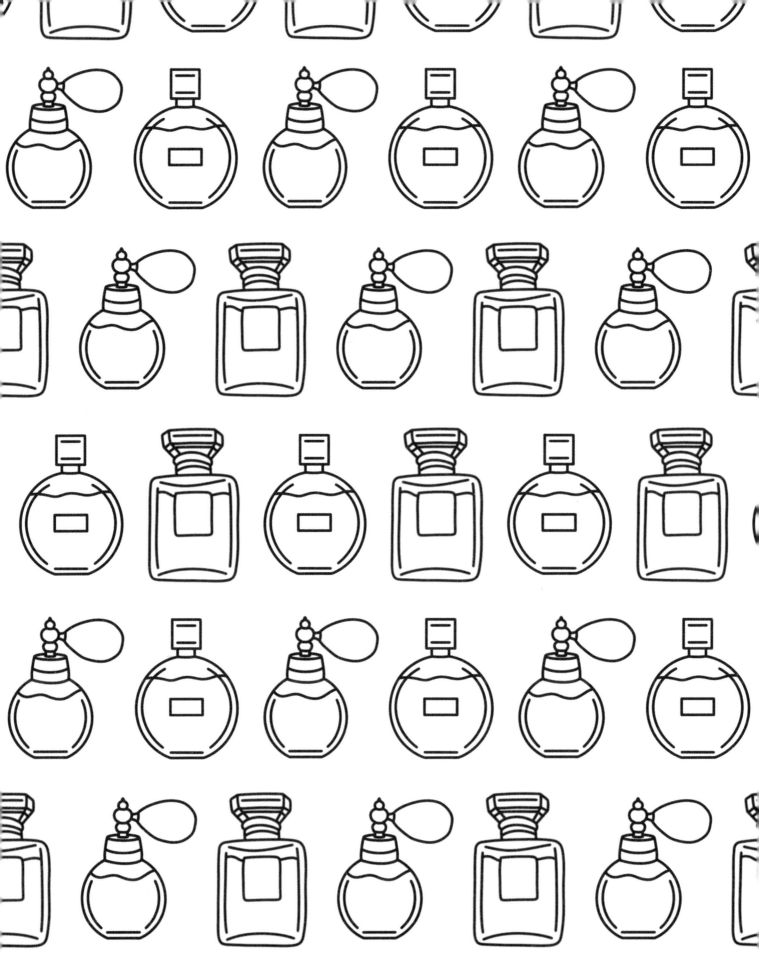

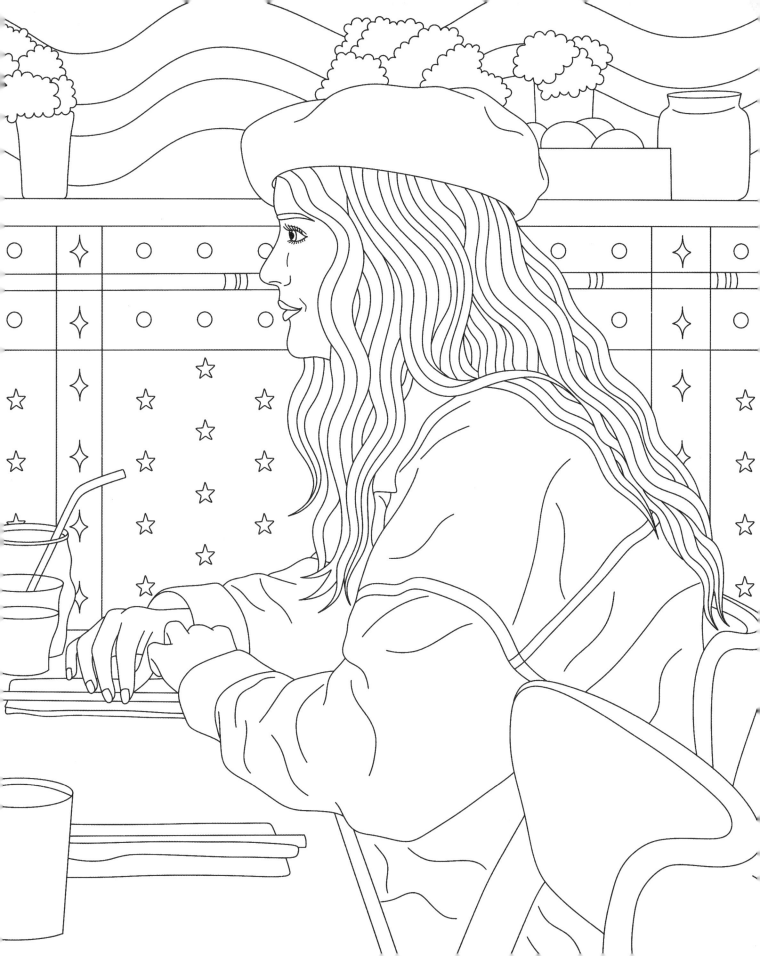

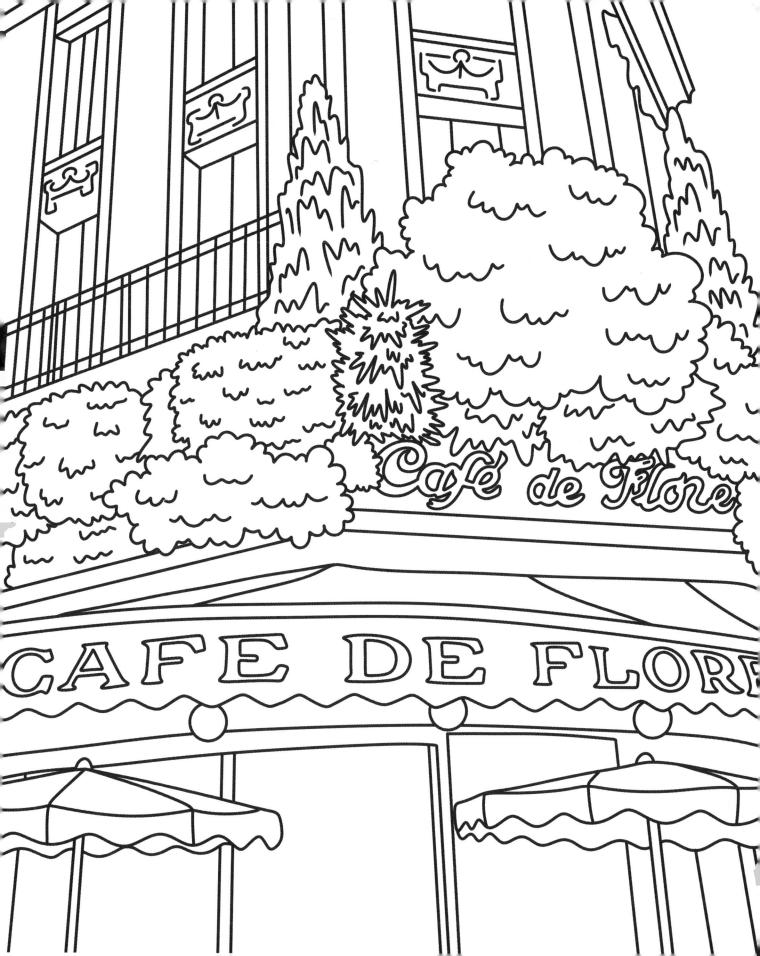

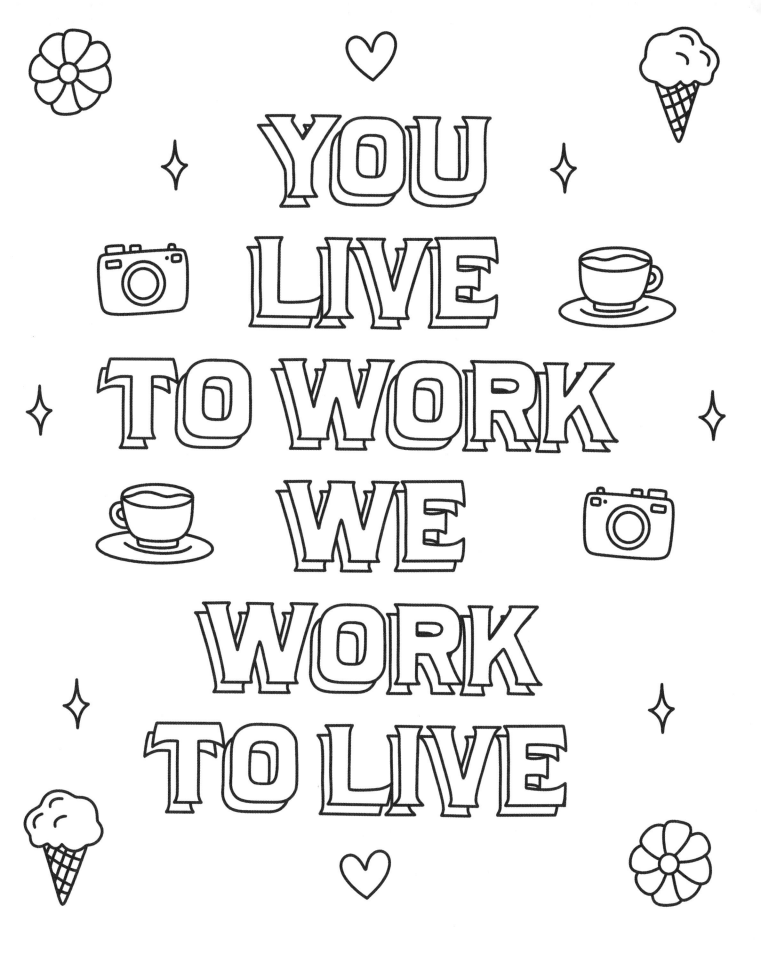

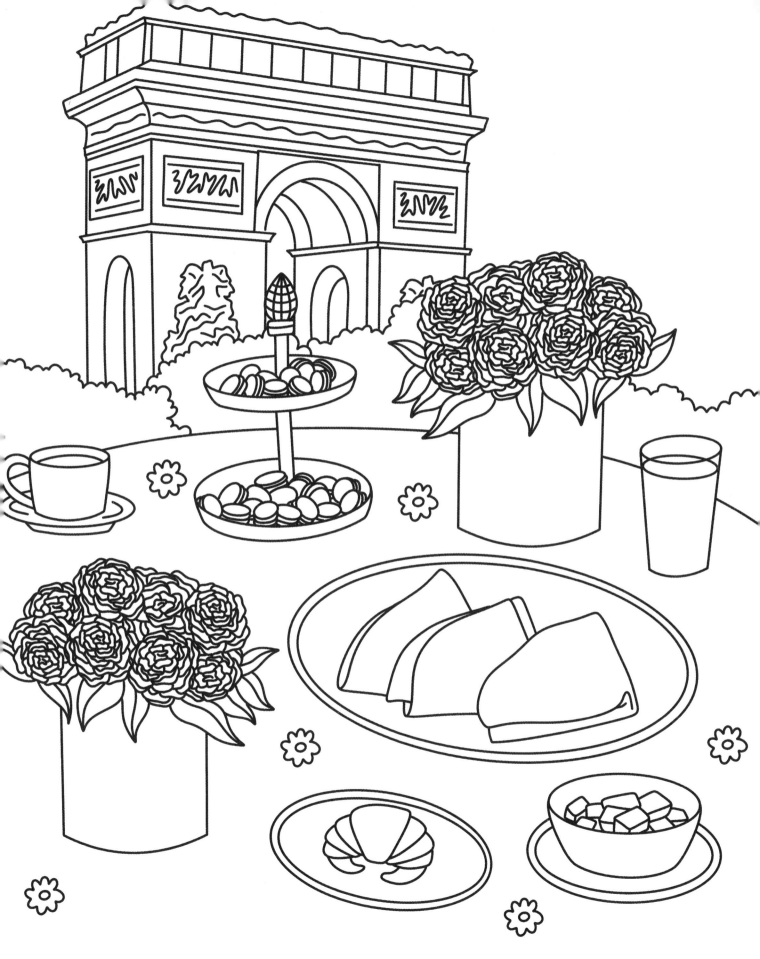

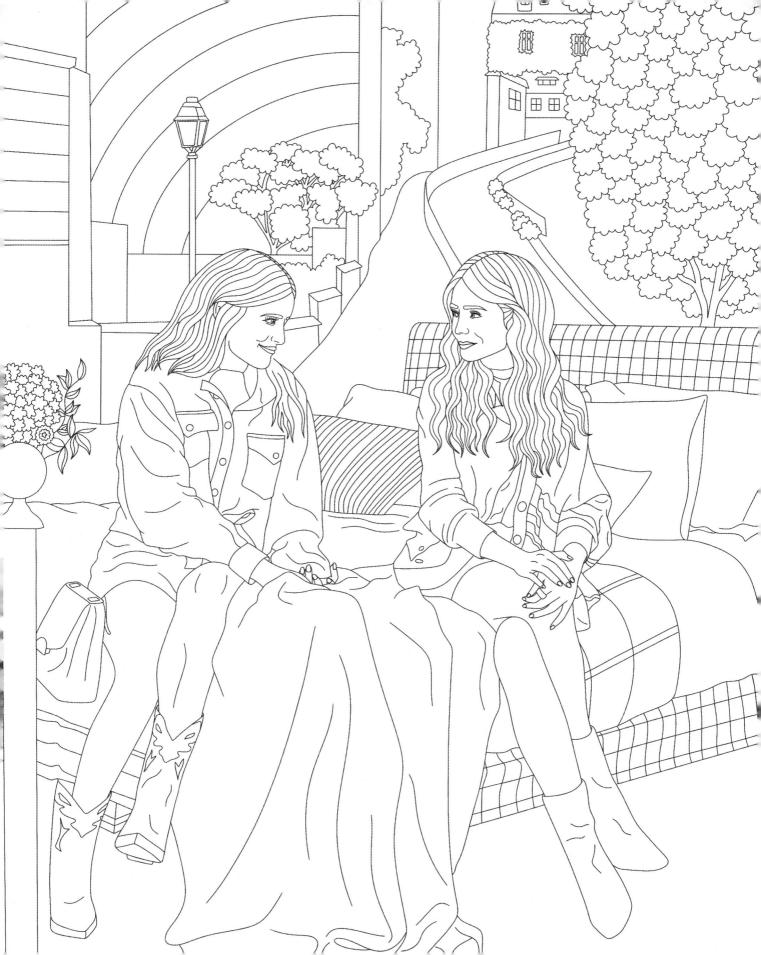

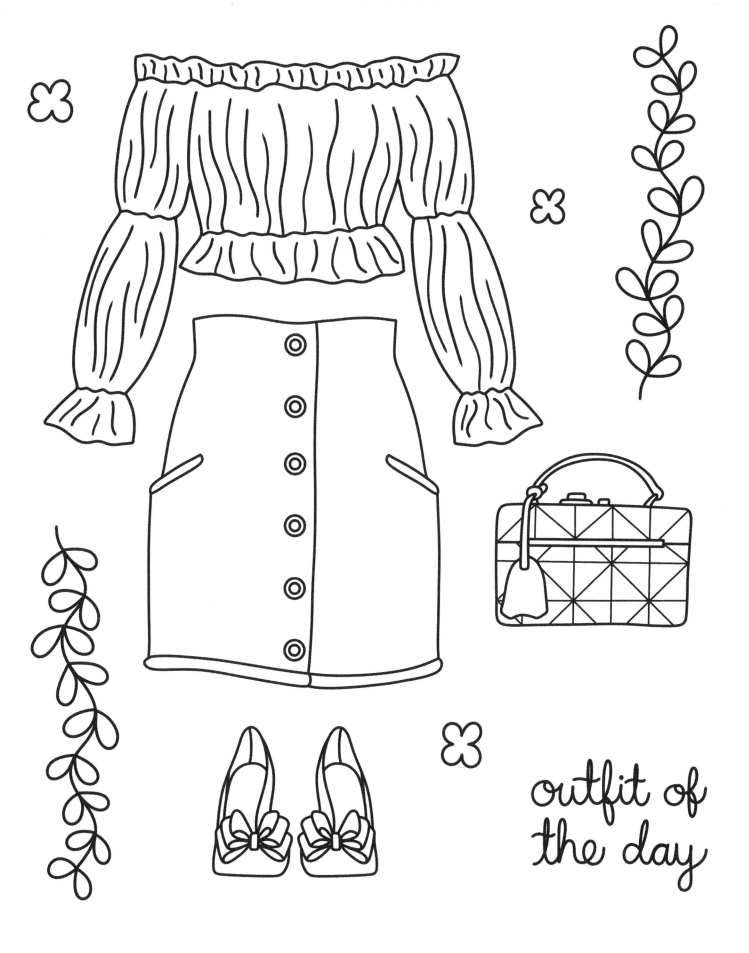

outfit of
the day

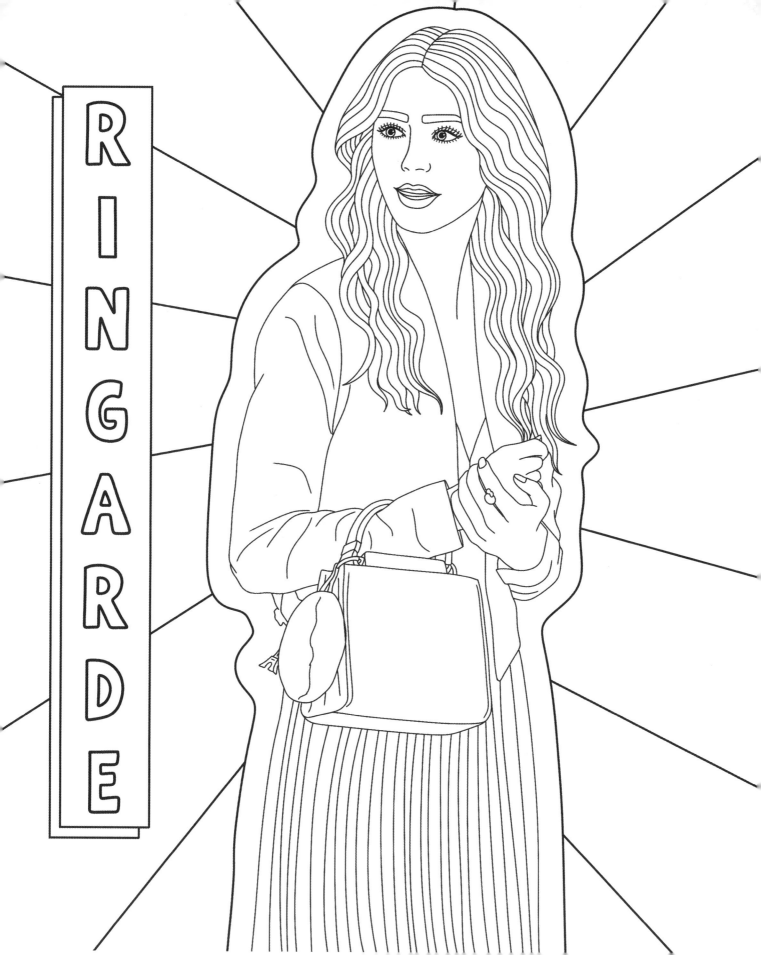

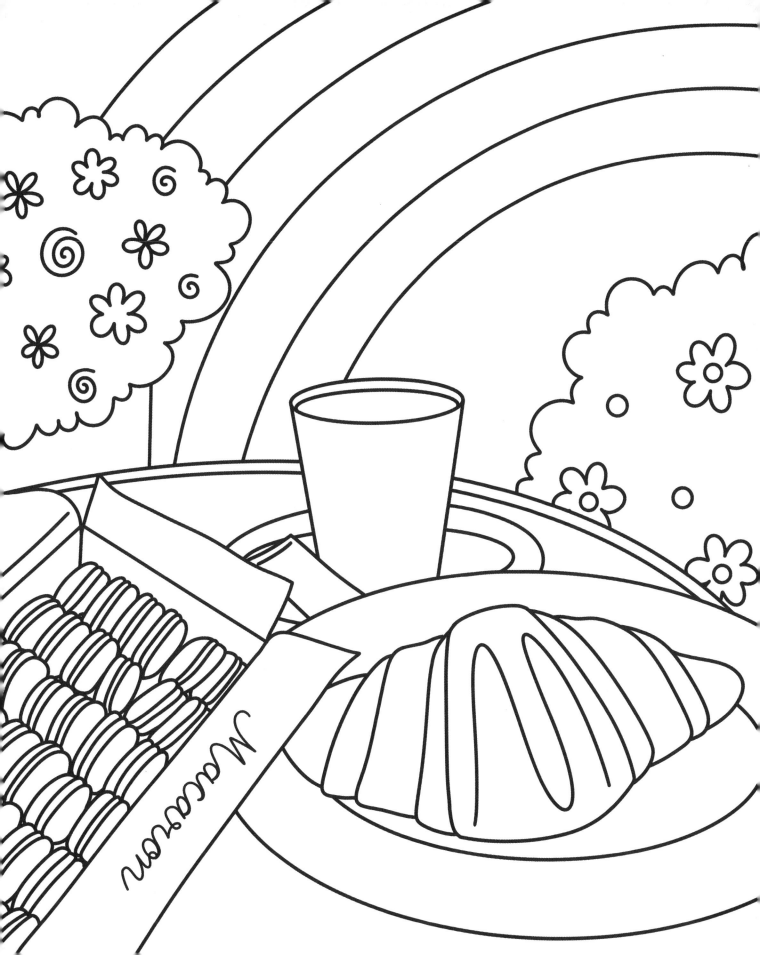

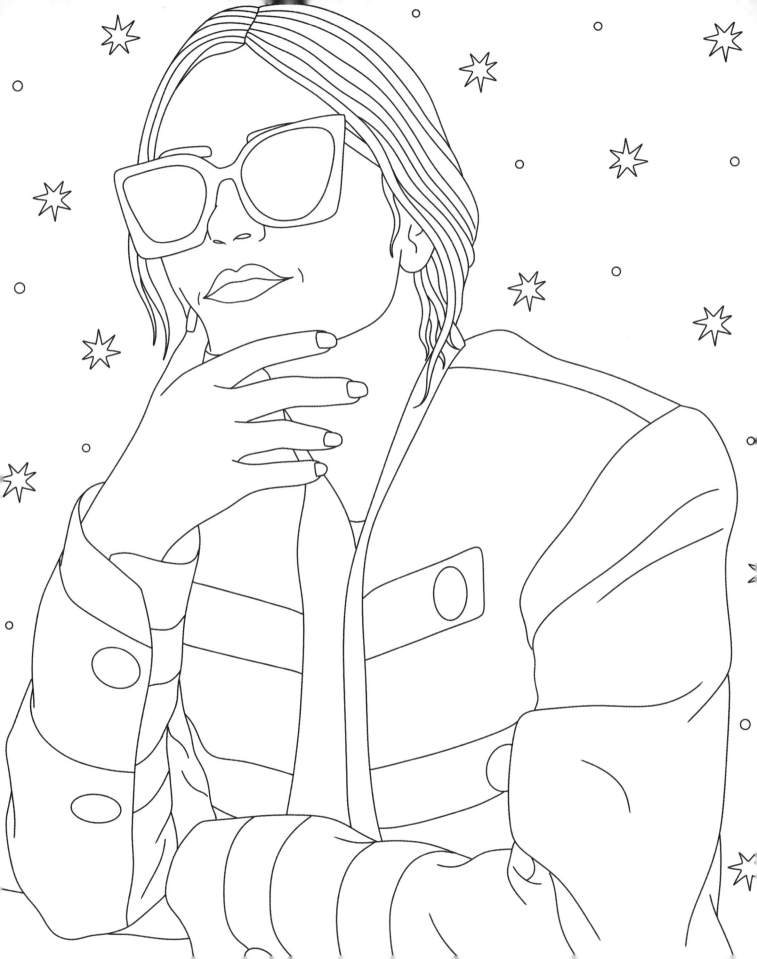

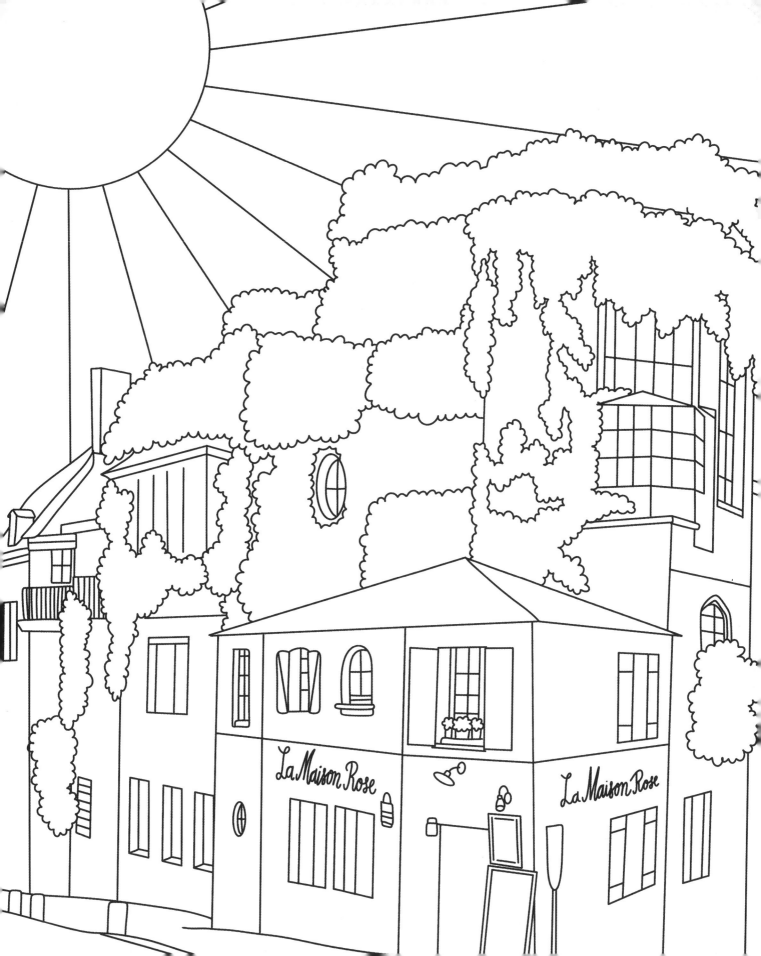

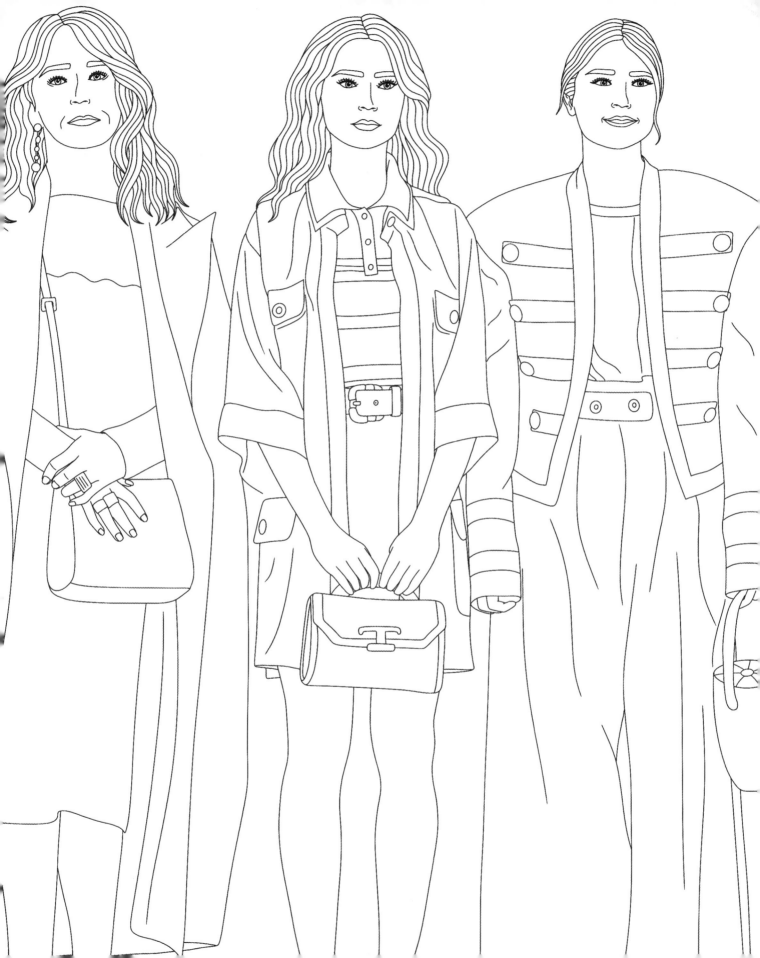

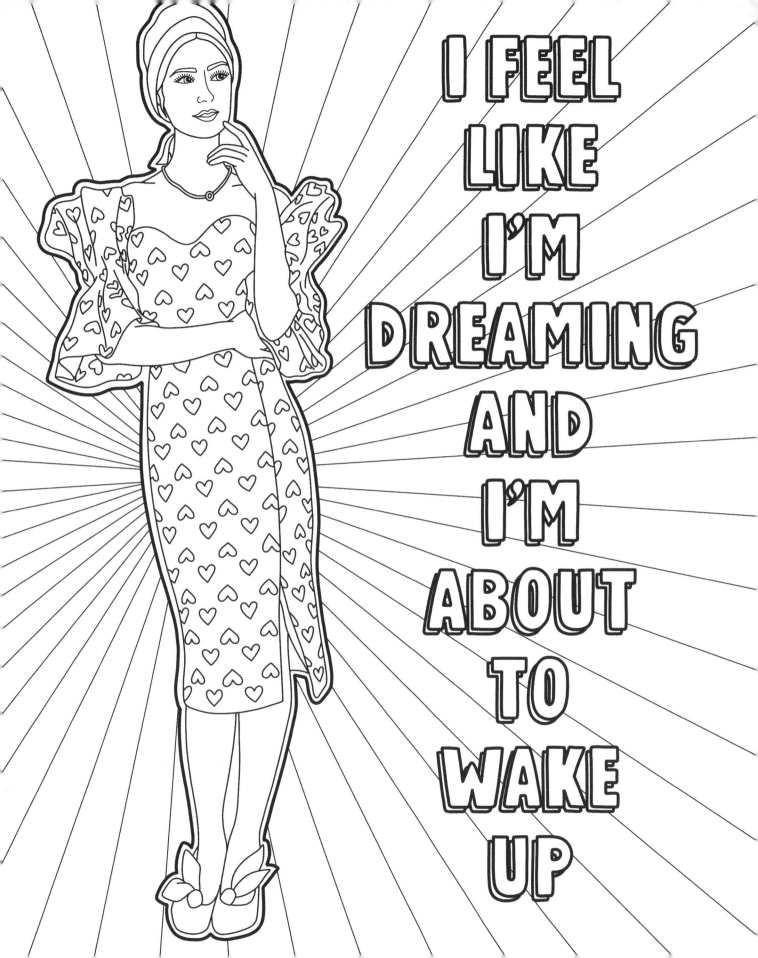

I FEEL LIKE I'M DREAMING AND I'M ABOUT TO WAKE UP

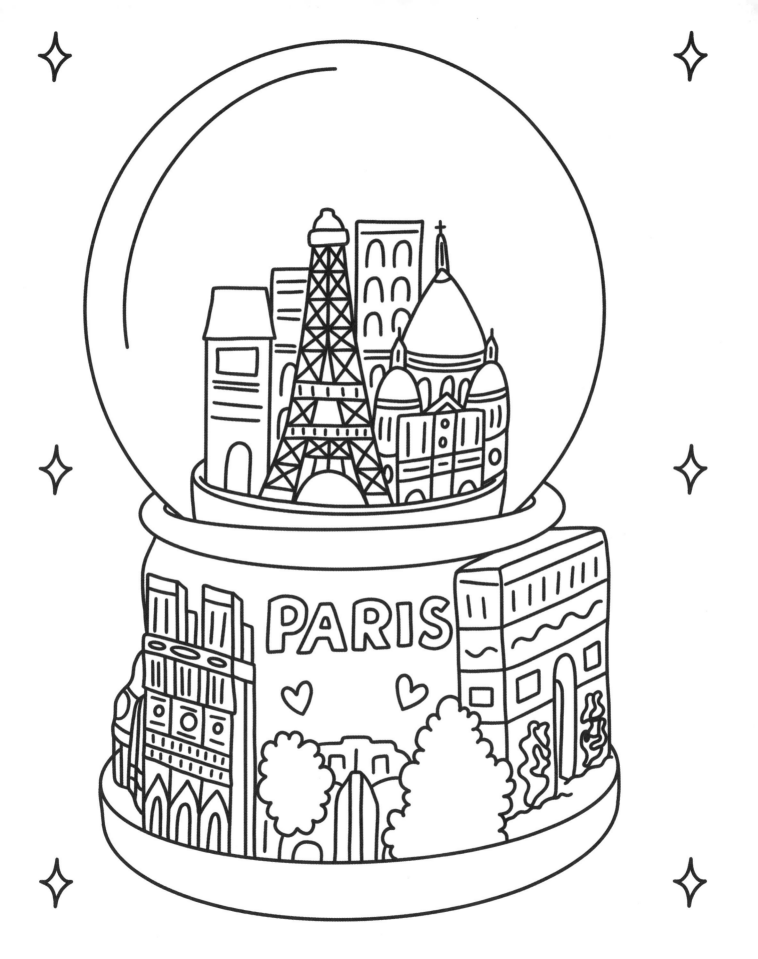

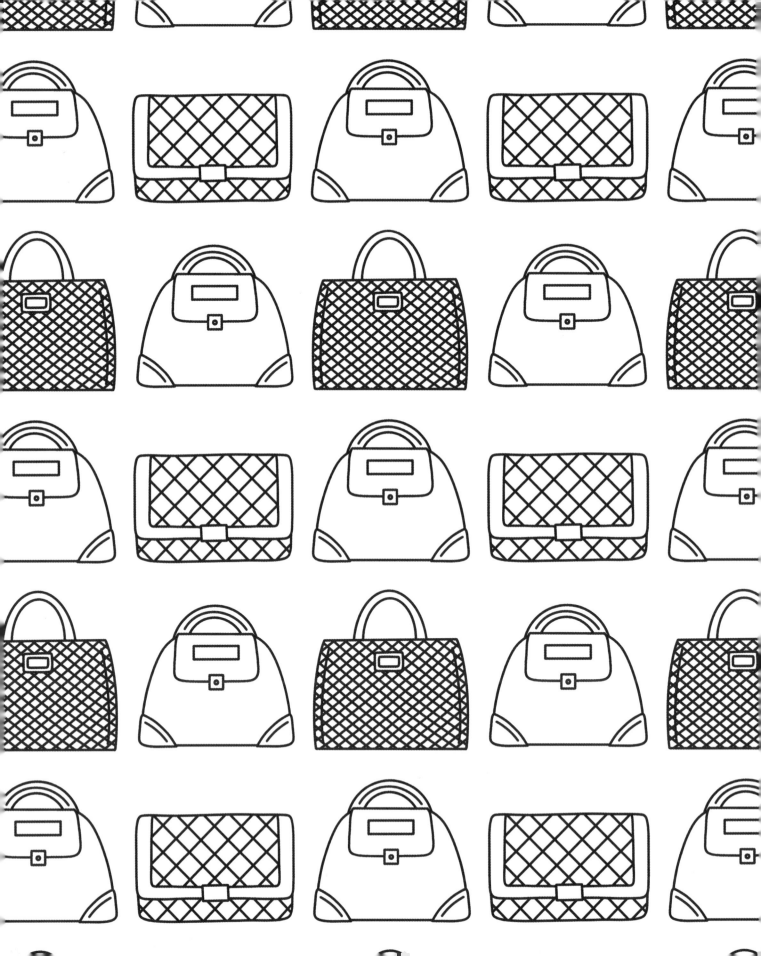

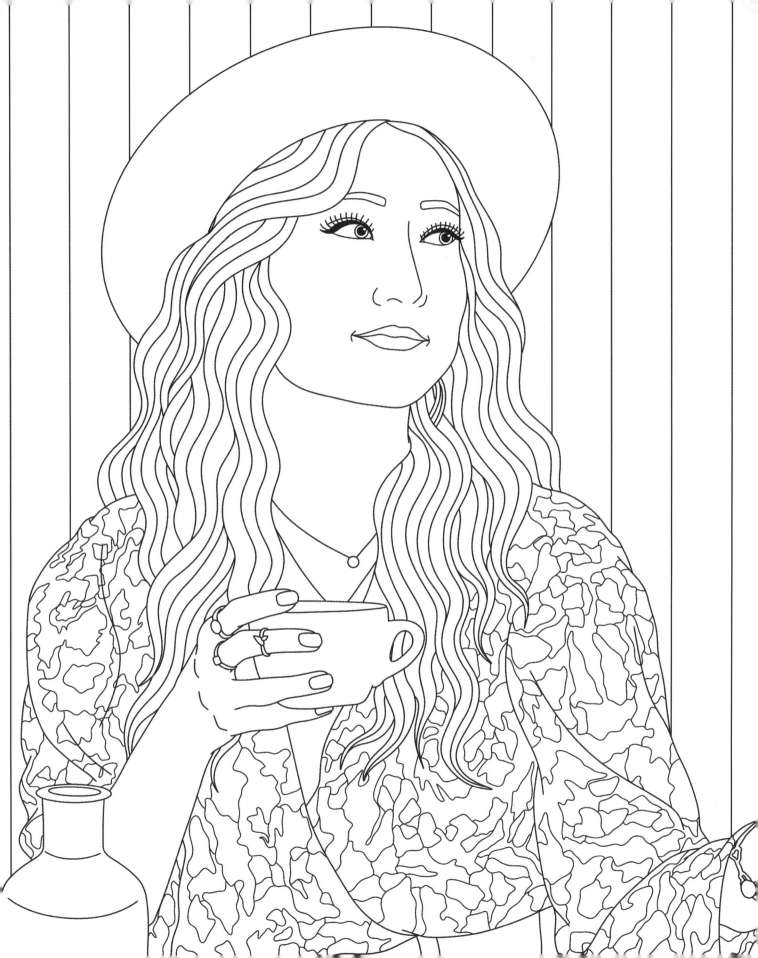

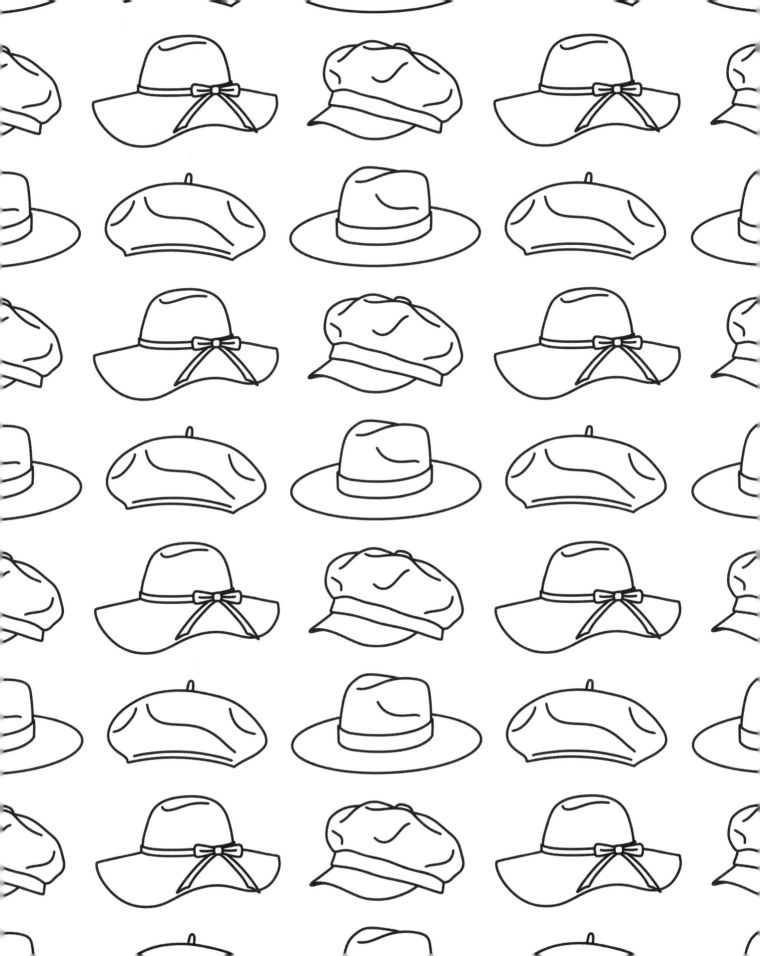

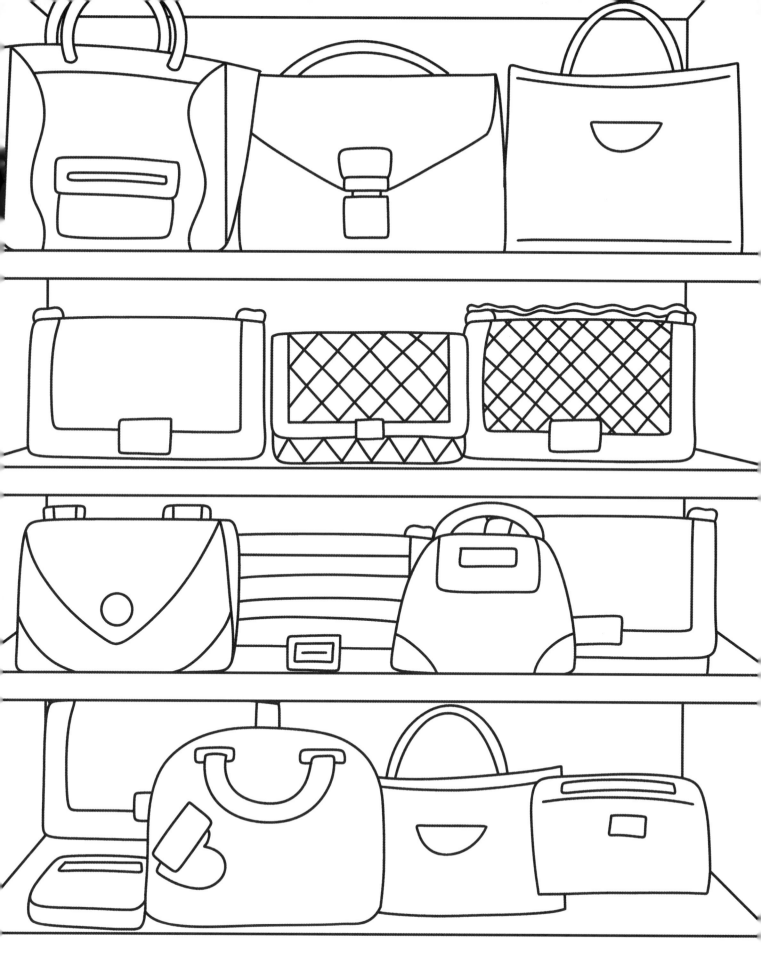

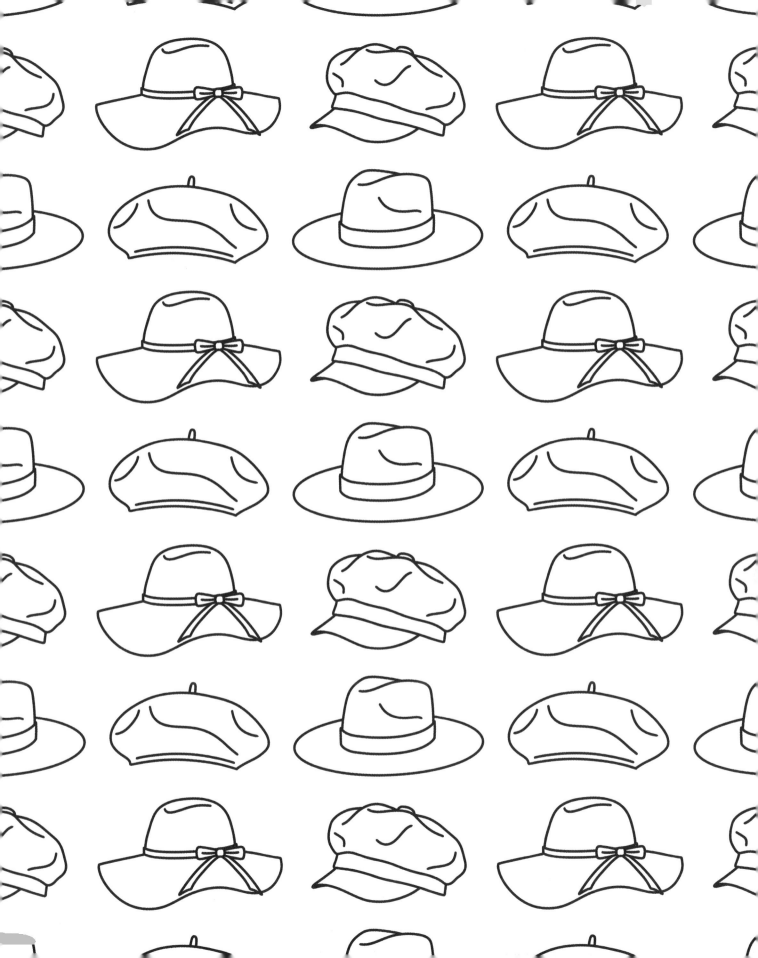

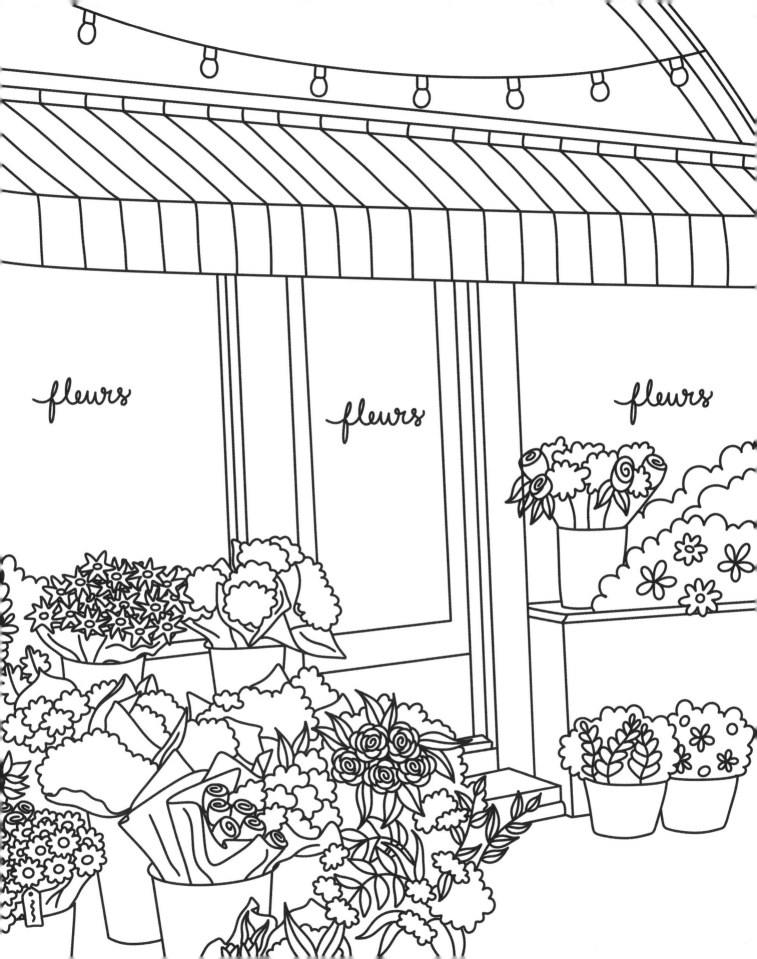

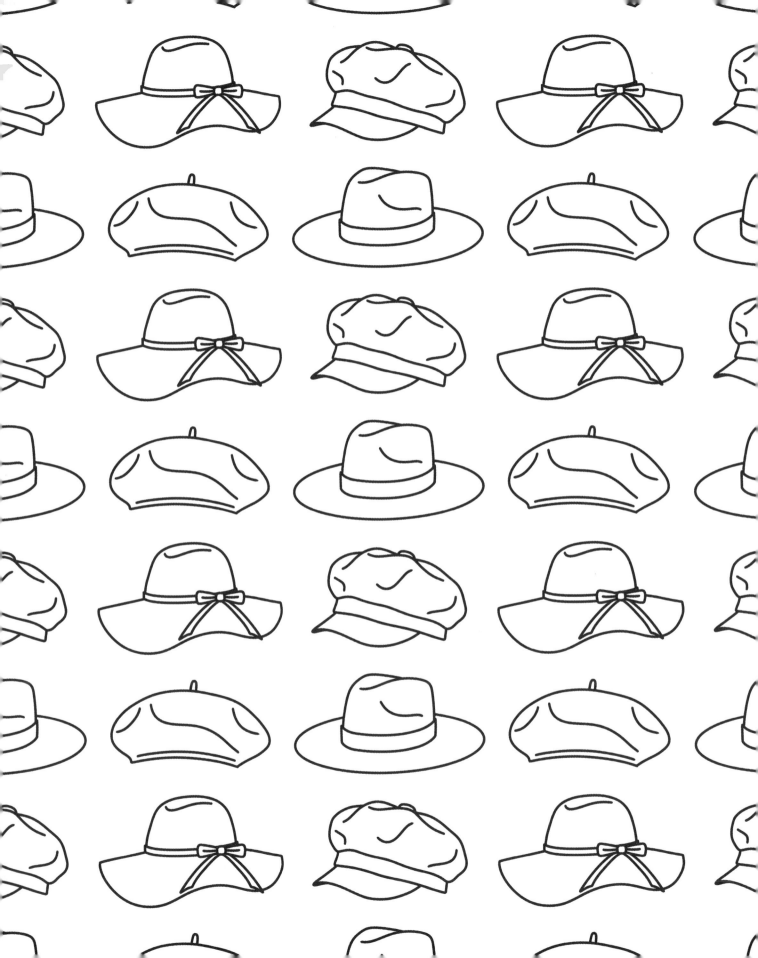

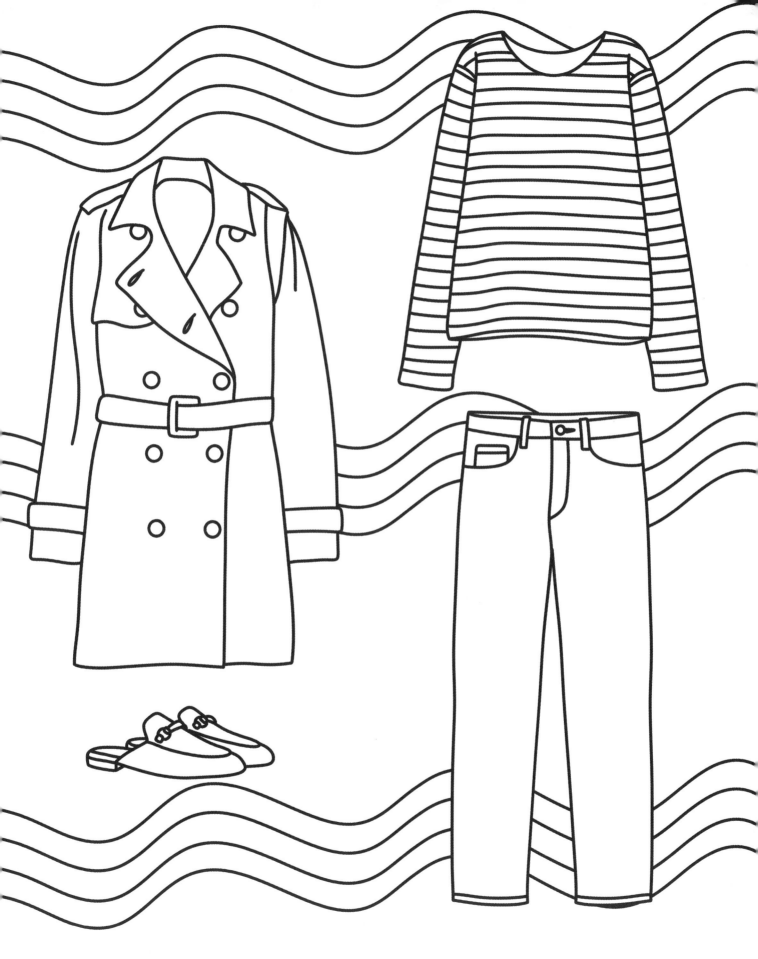

# WE NEED TO LOOK AT THINGS FROM A DIFFERENT PERSPECTIVE

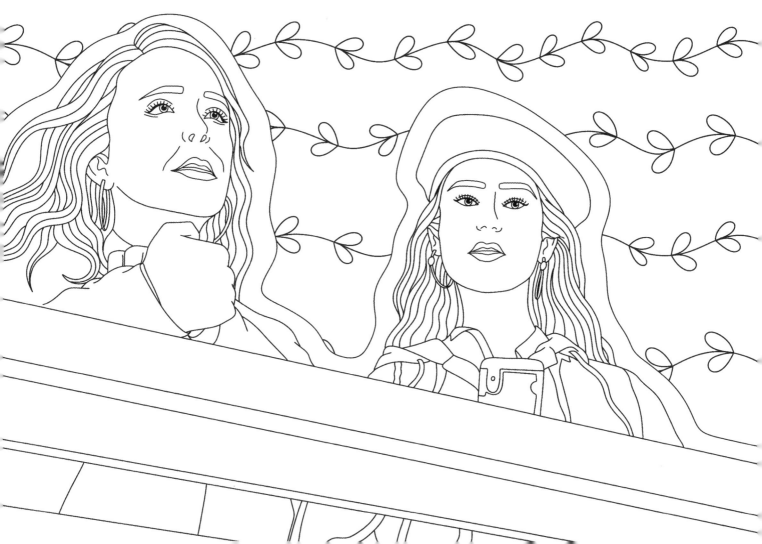

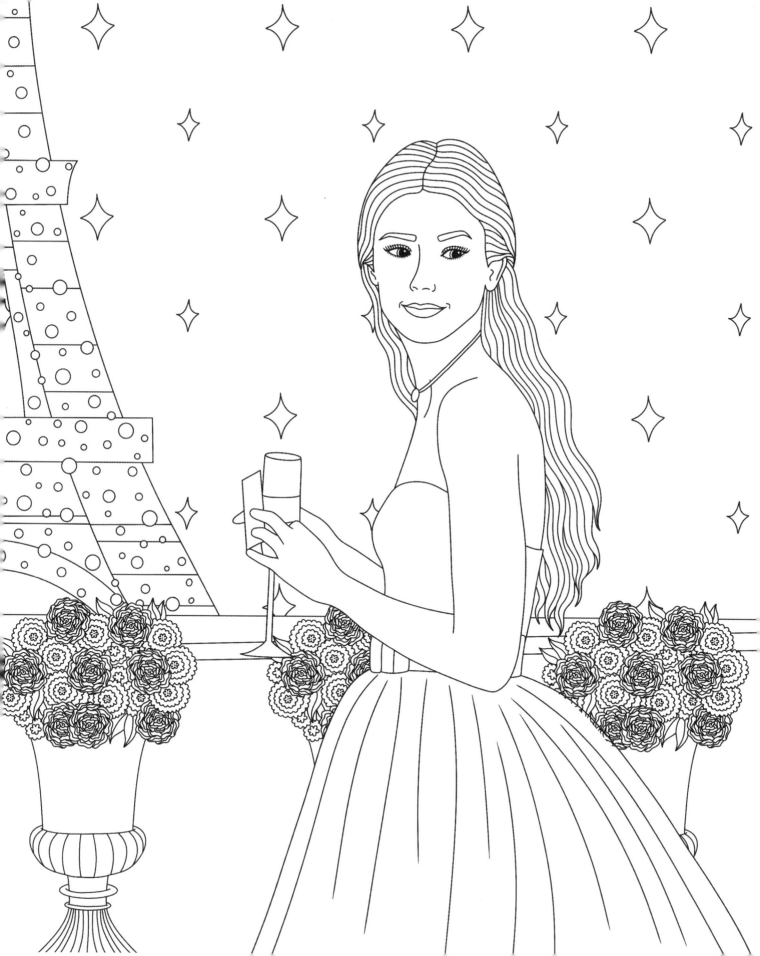

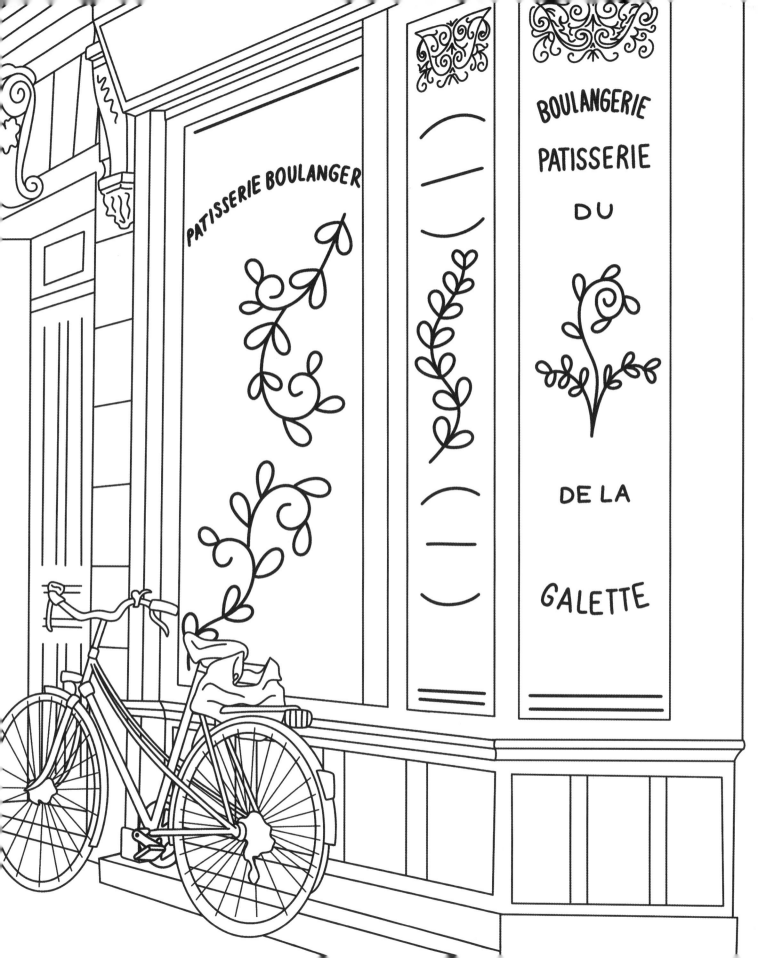

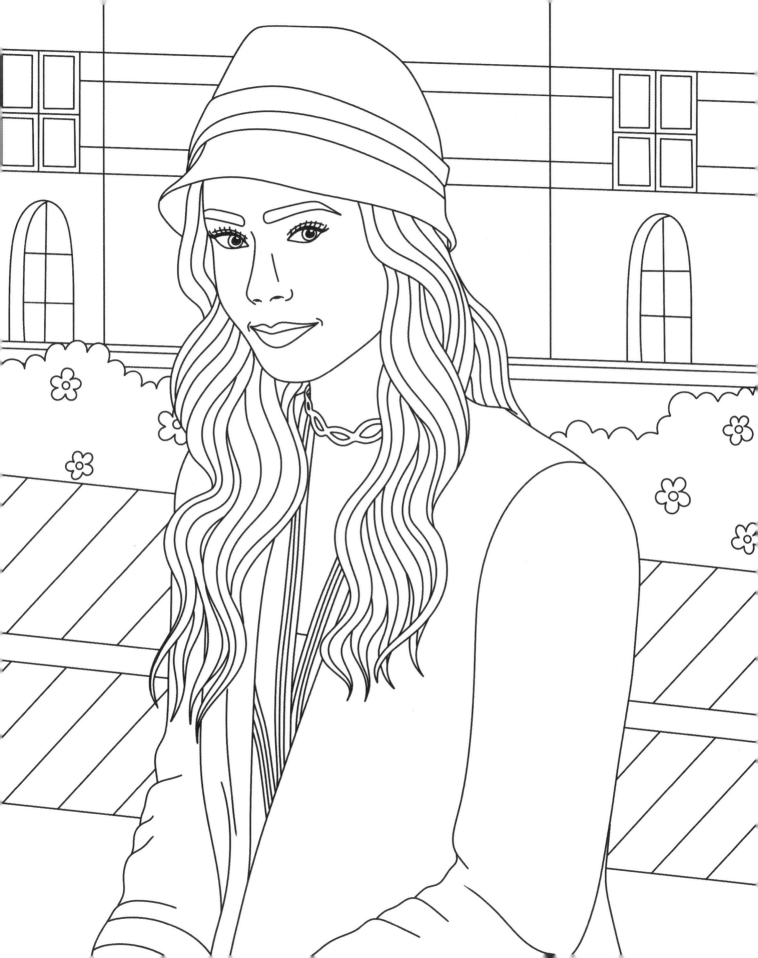

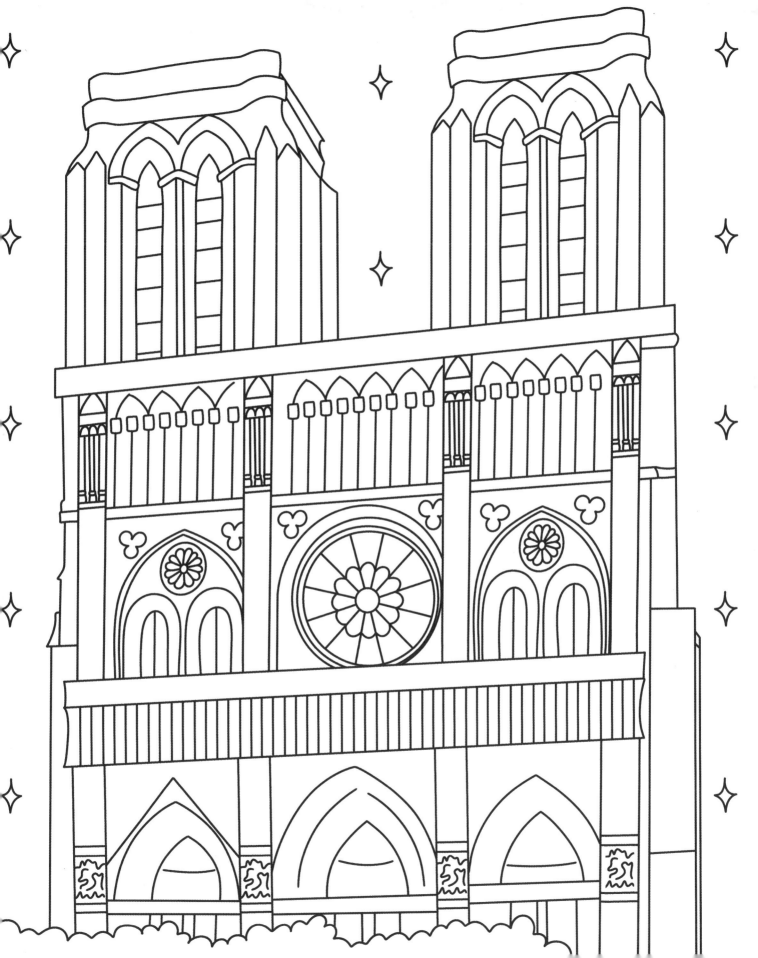

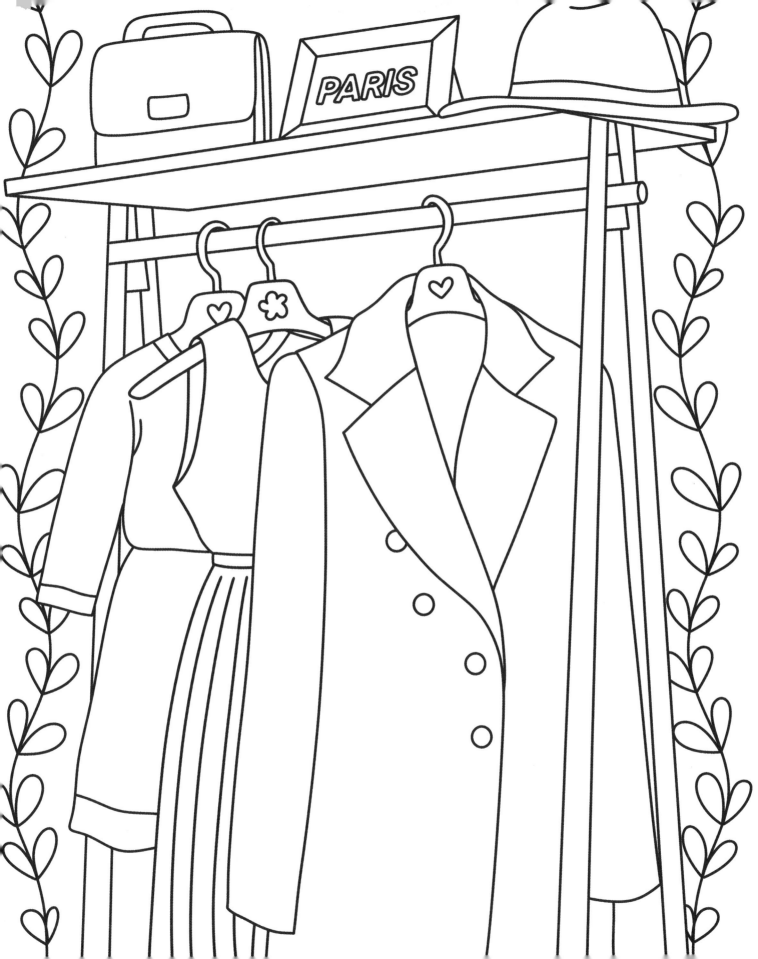

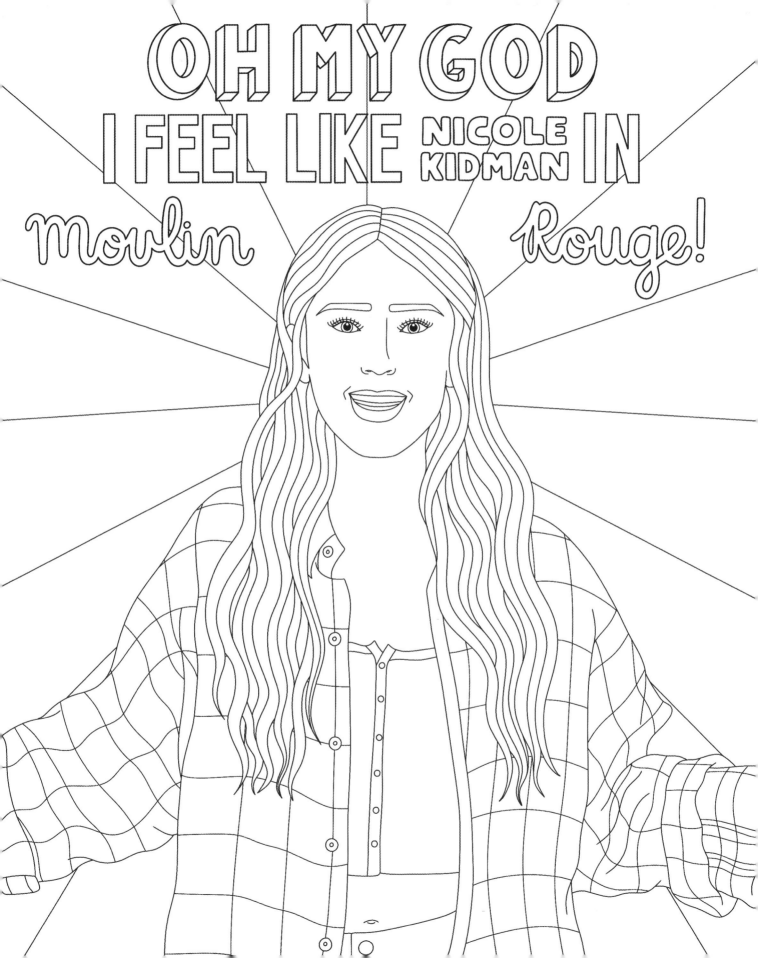

Aujourd'hui, c'est demain et hier qui s'épousent

# Musée du Louvre

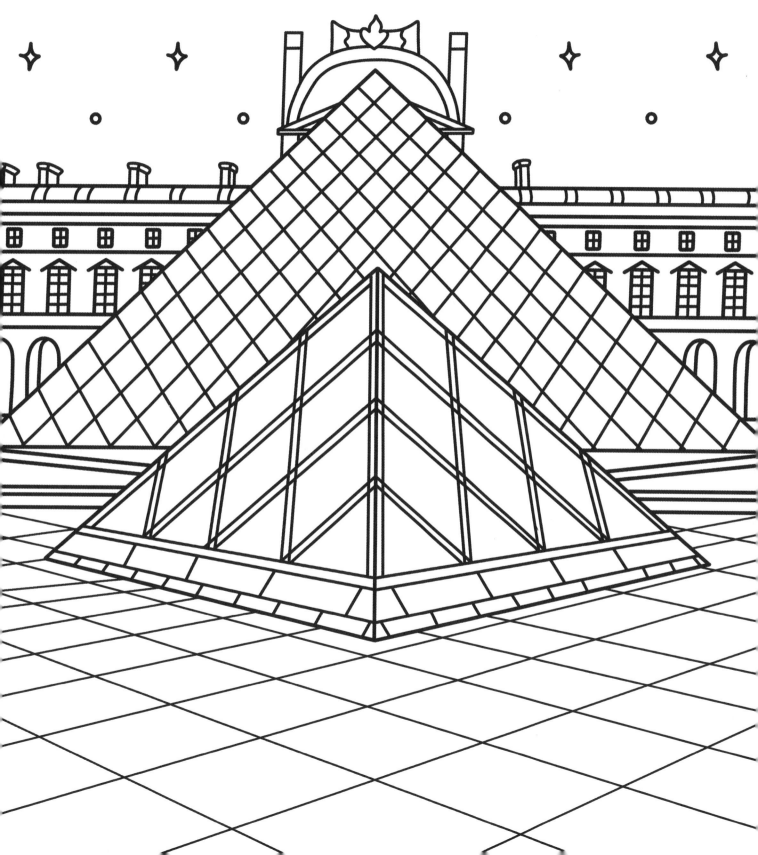

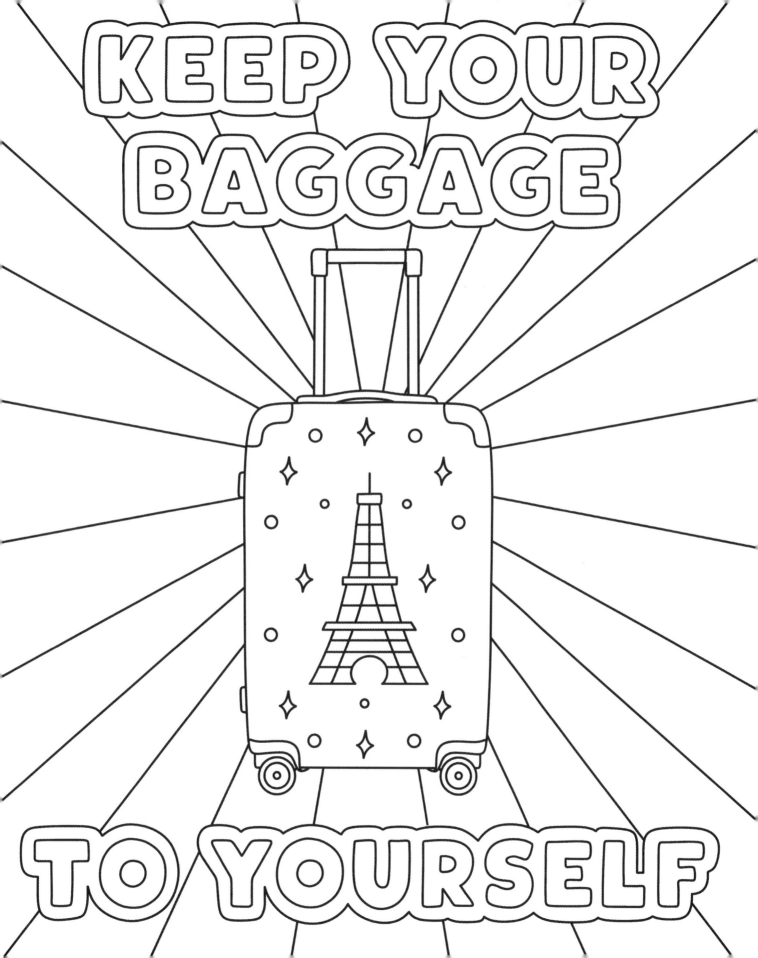

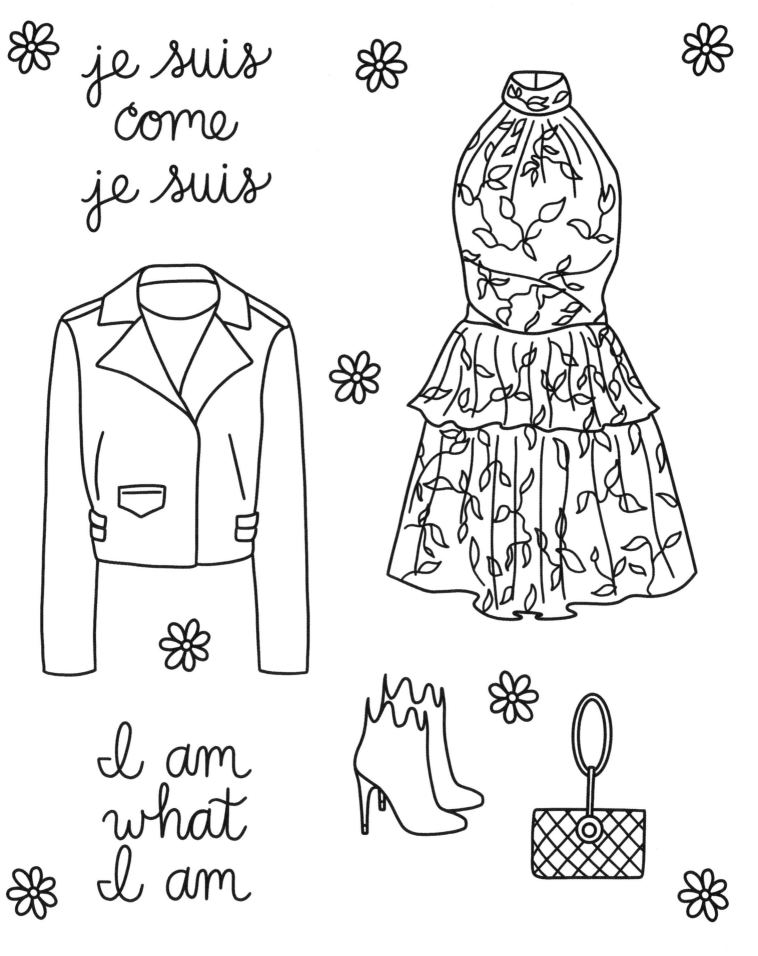

La vie est une fleur.
L'amour en est le miel.
-Victor Hugo

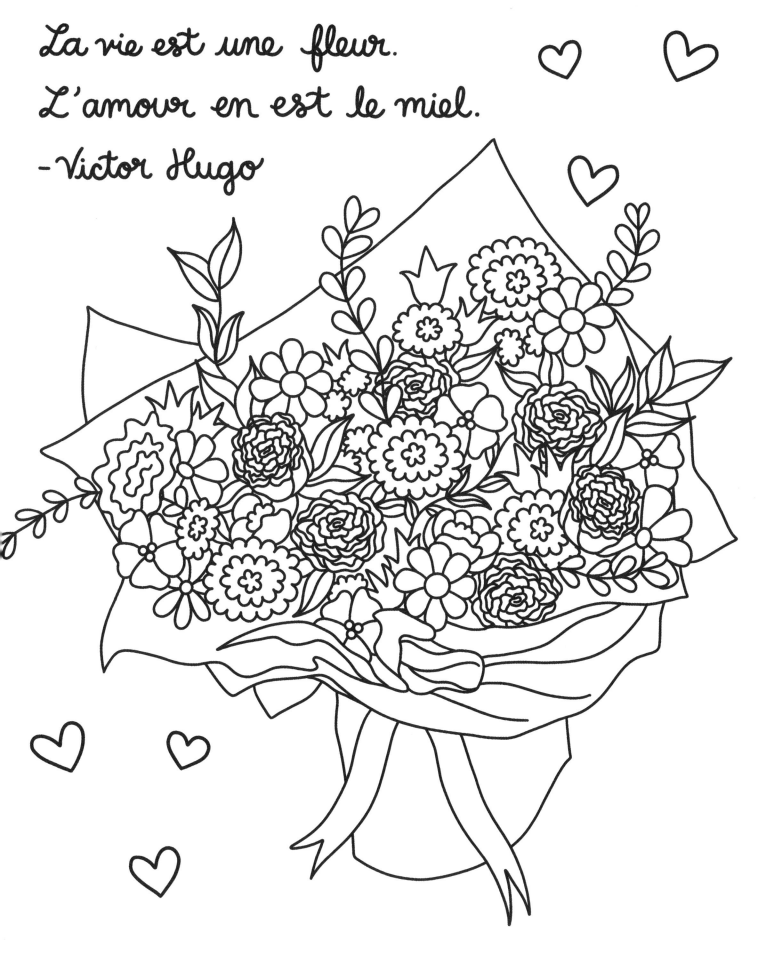

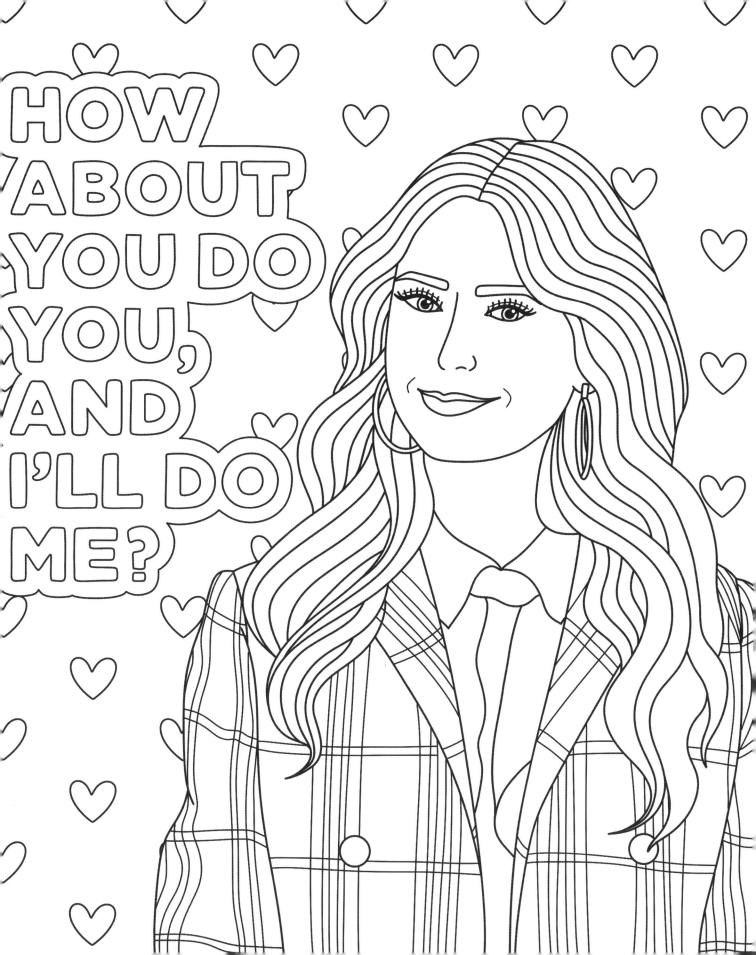

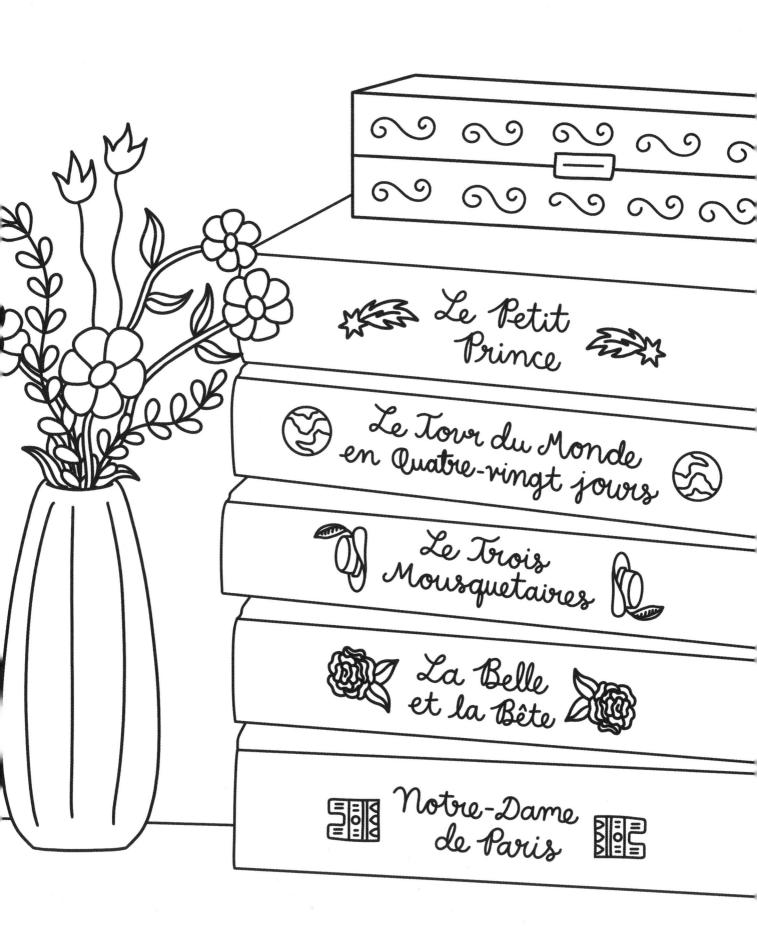

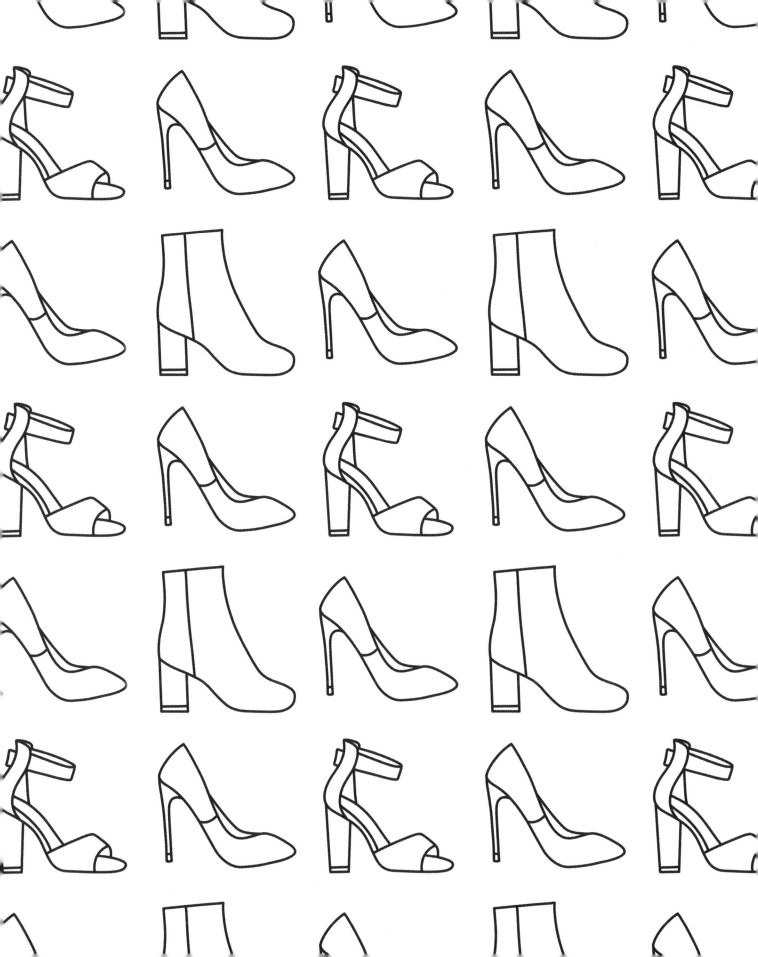

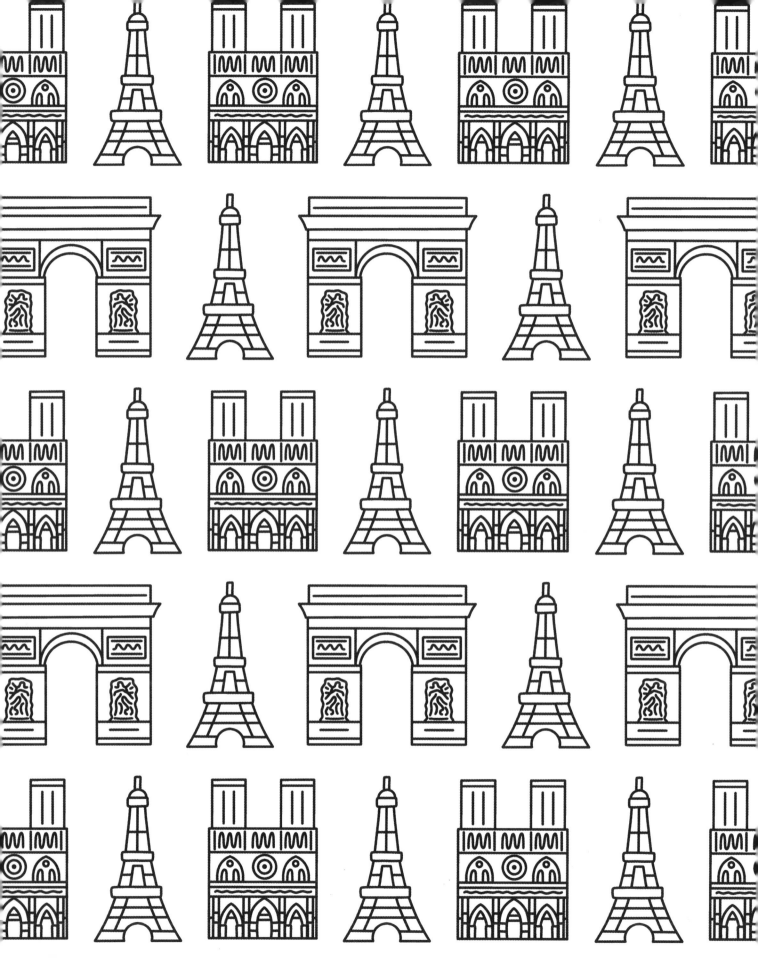

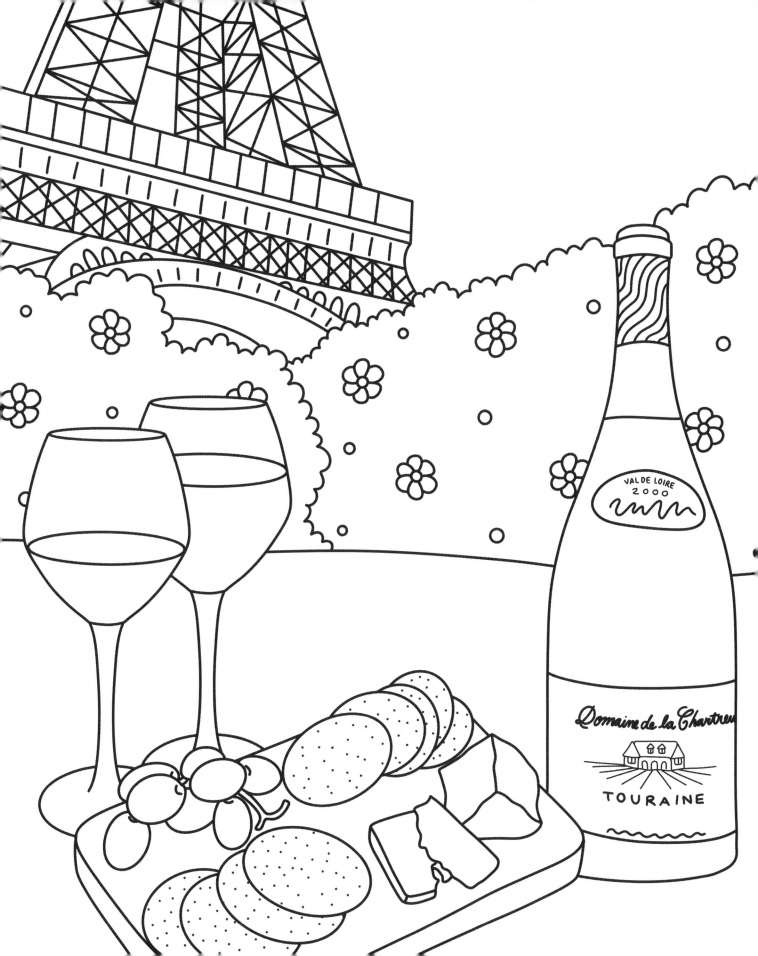

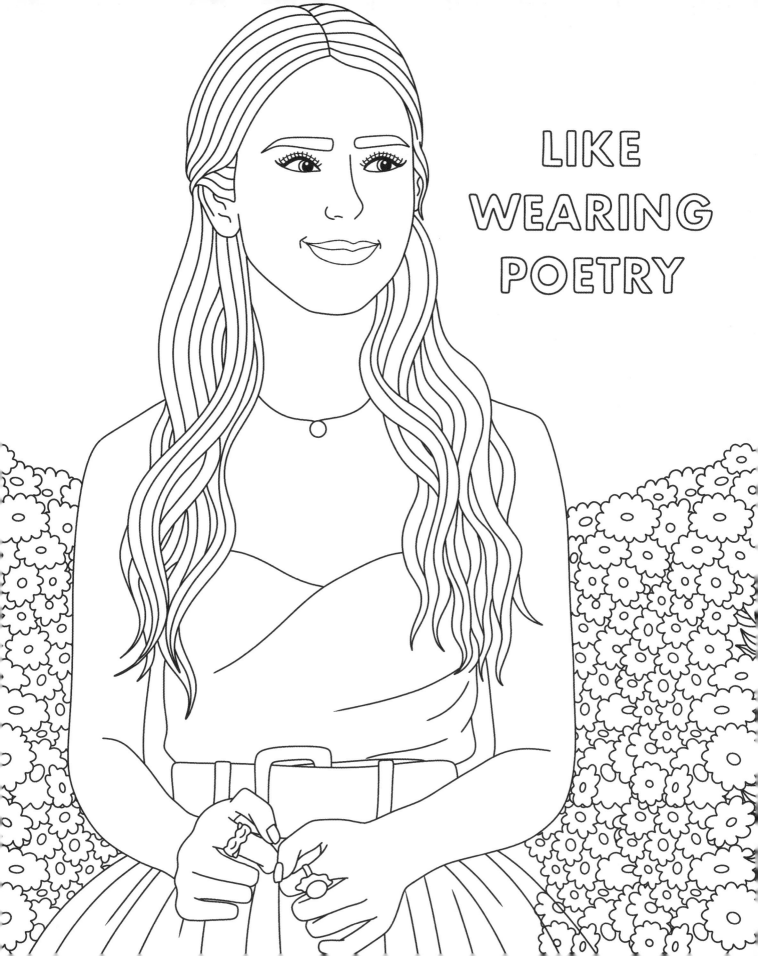

LIKE WEARING POETRY

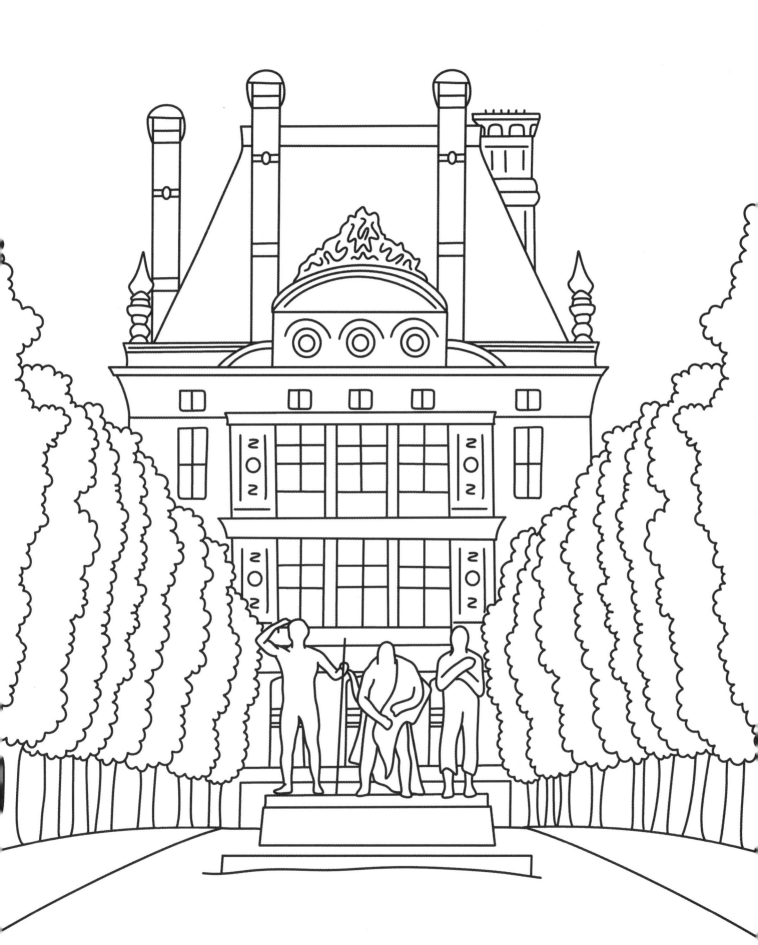

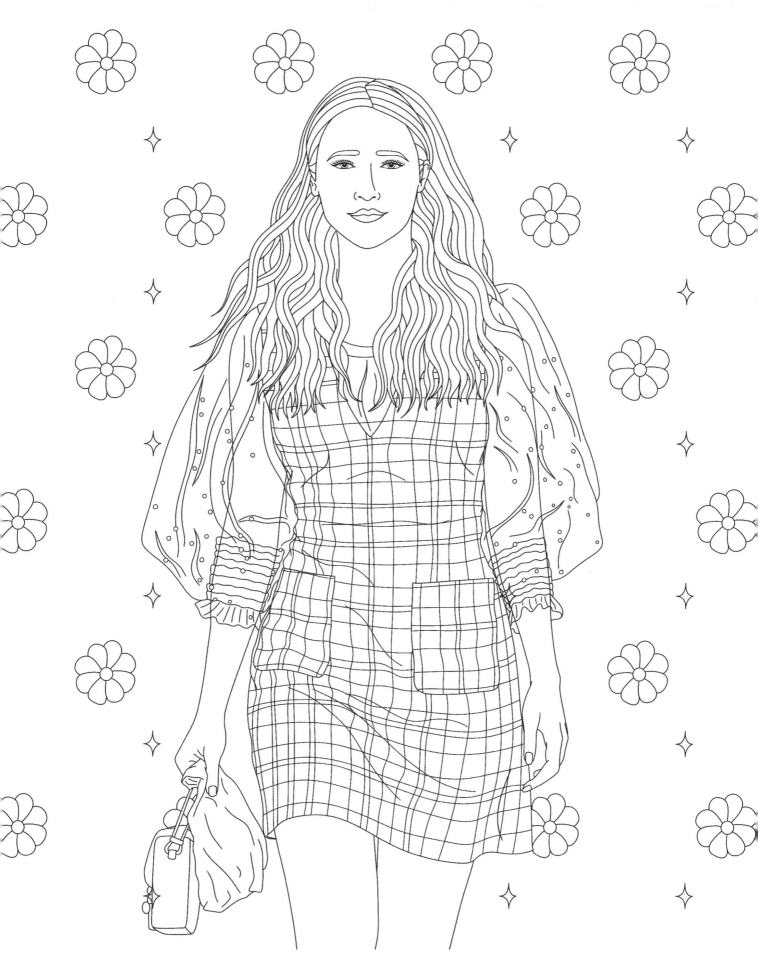

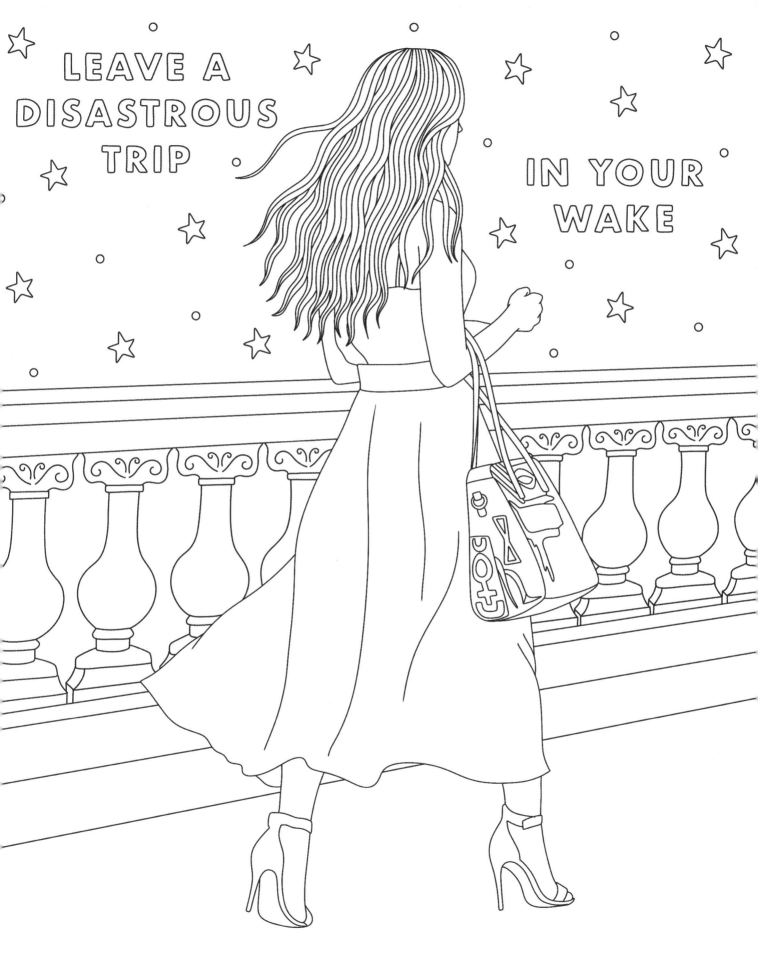

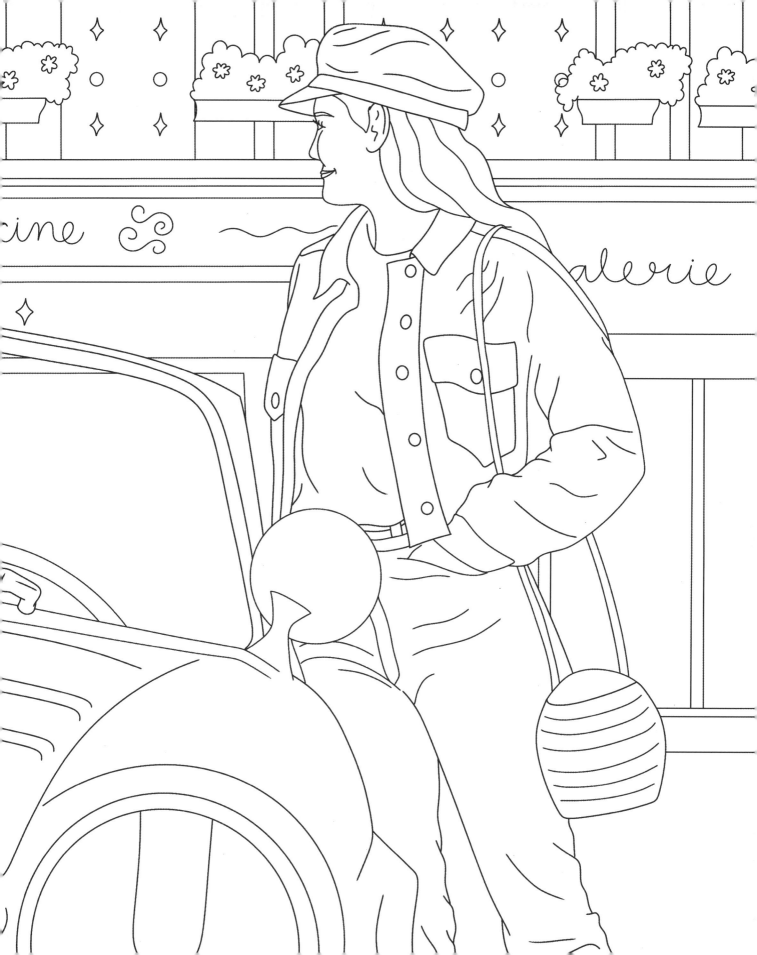

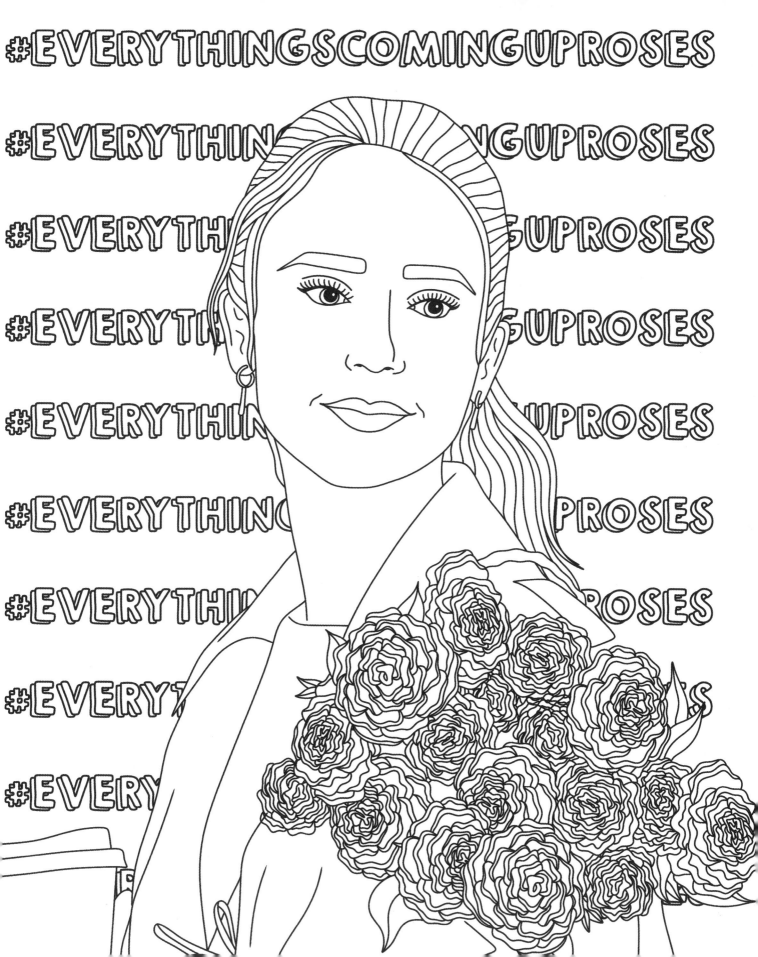

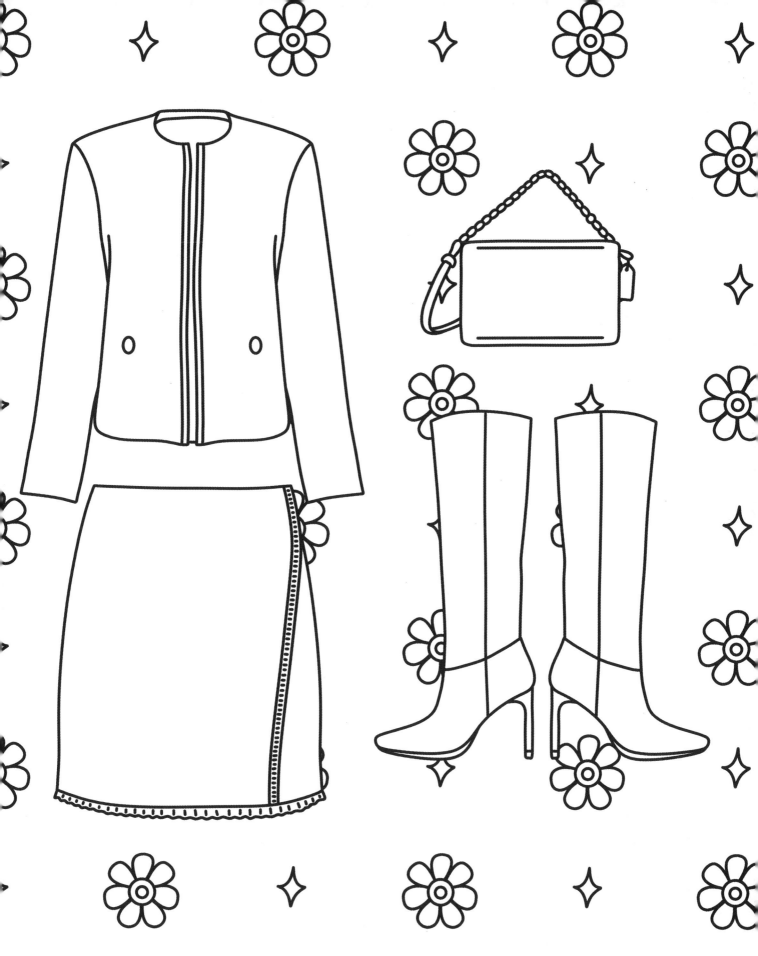

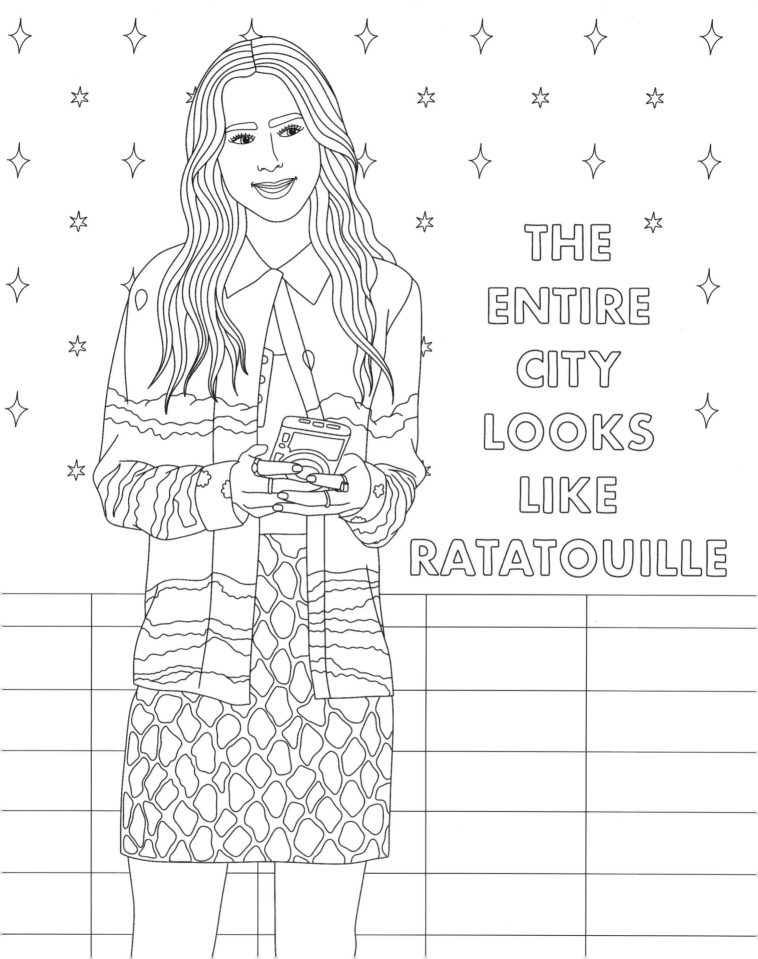

THE ENTIRE CITY LOOKS LIKE RATATOUILLE

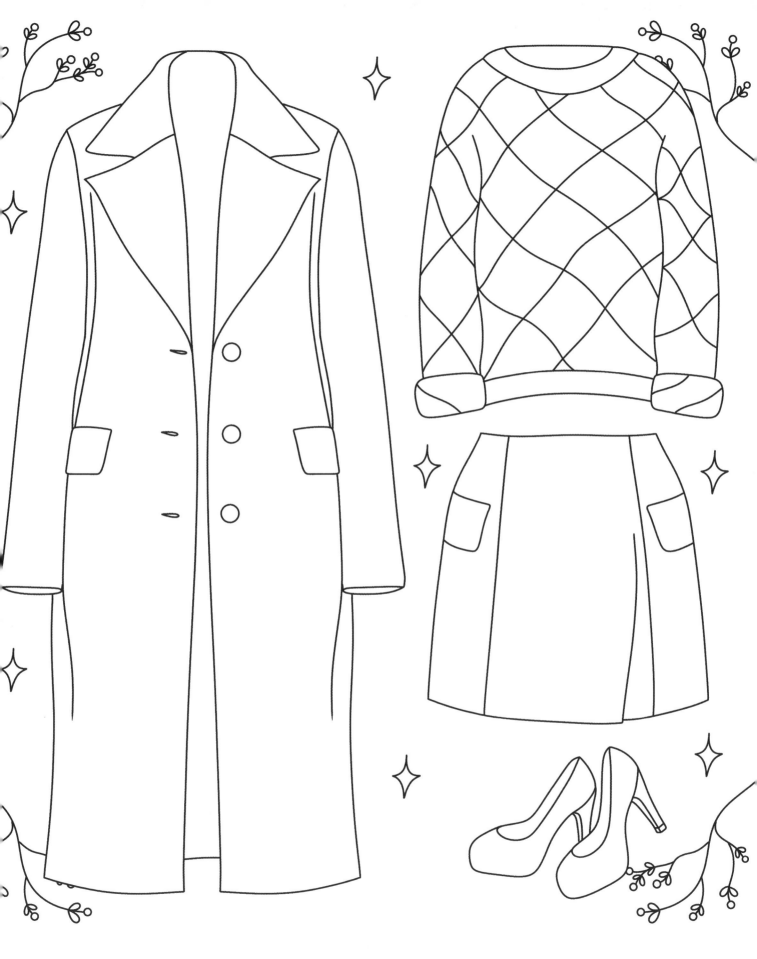

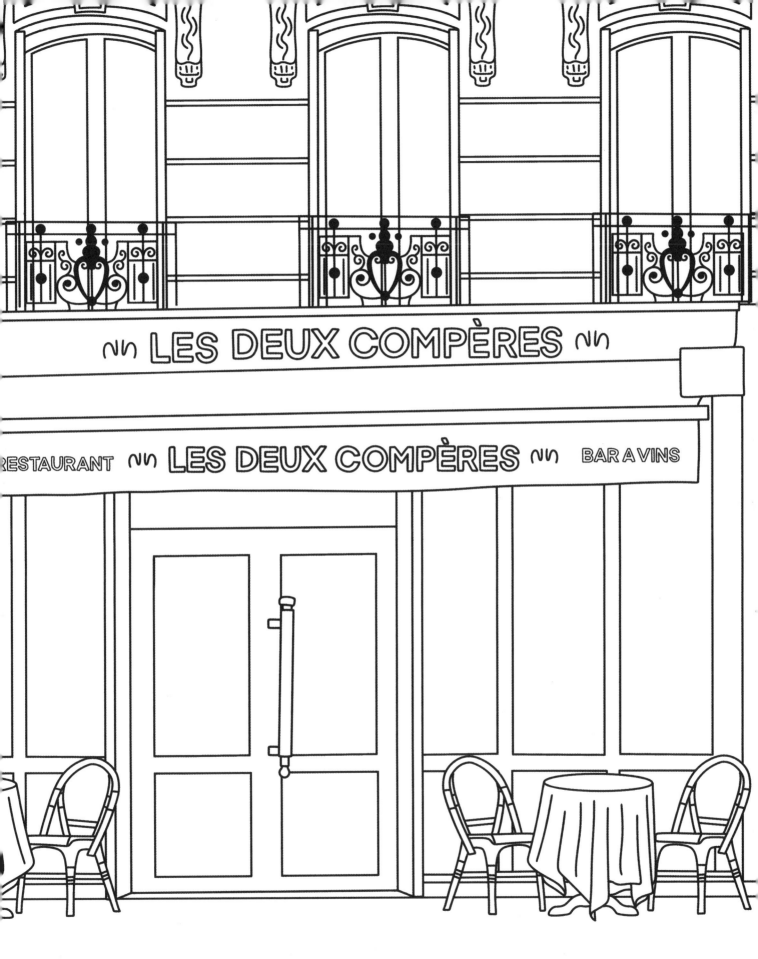

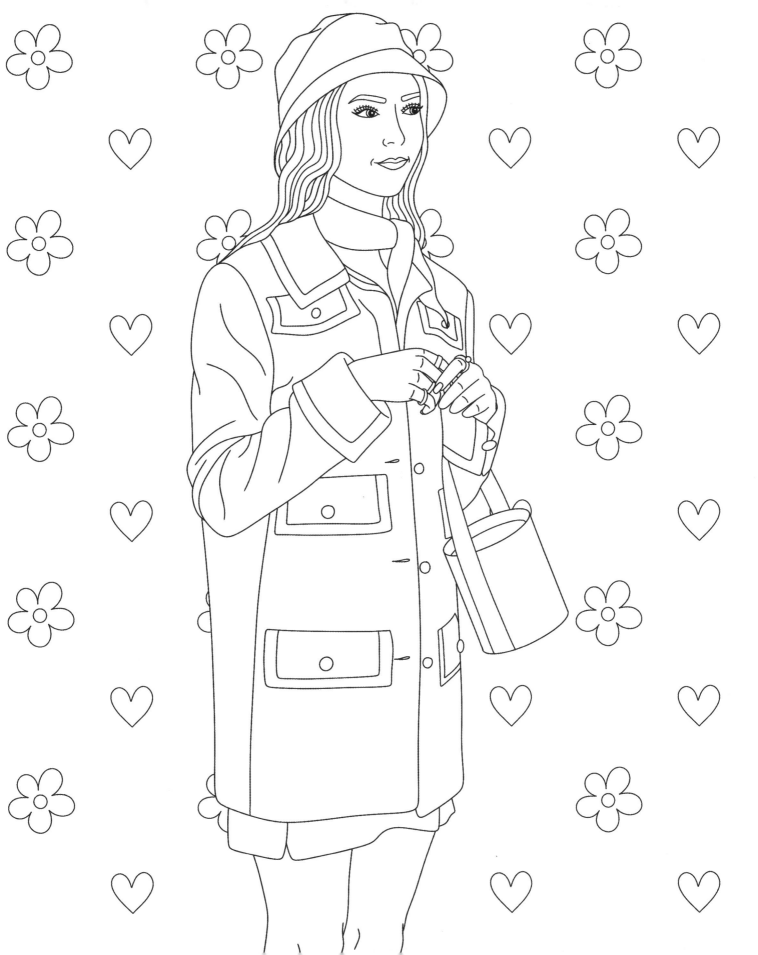

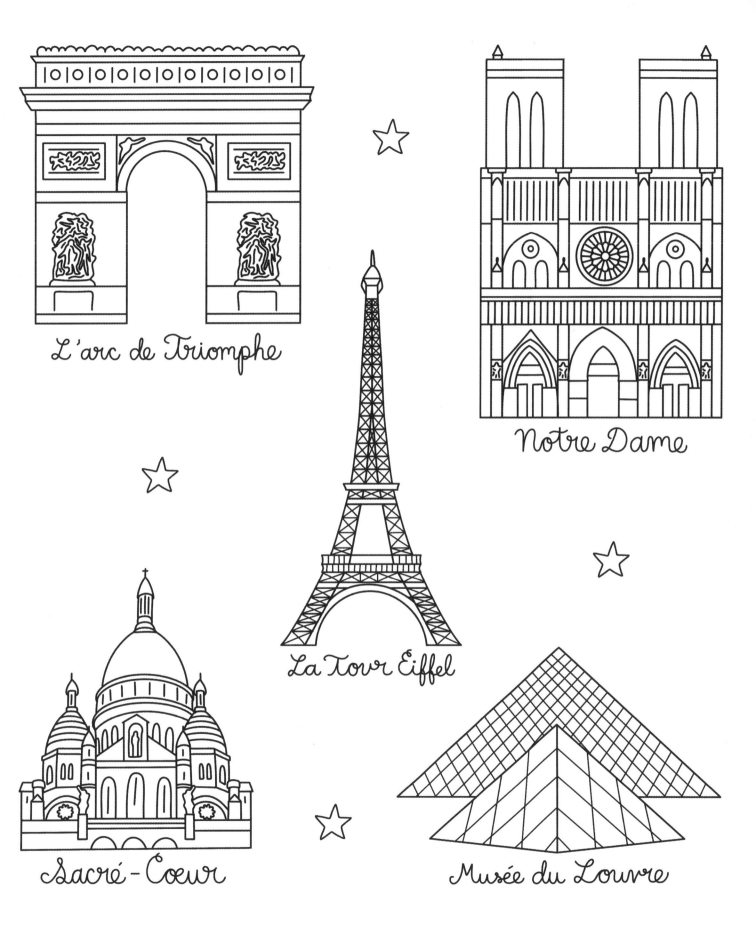

L'arc de Triomphe

Notre Dame

La Tour Eiffel

Sacré-Coeur

Musée du Louvre

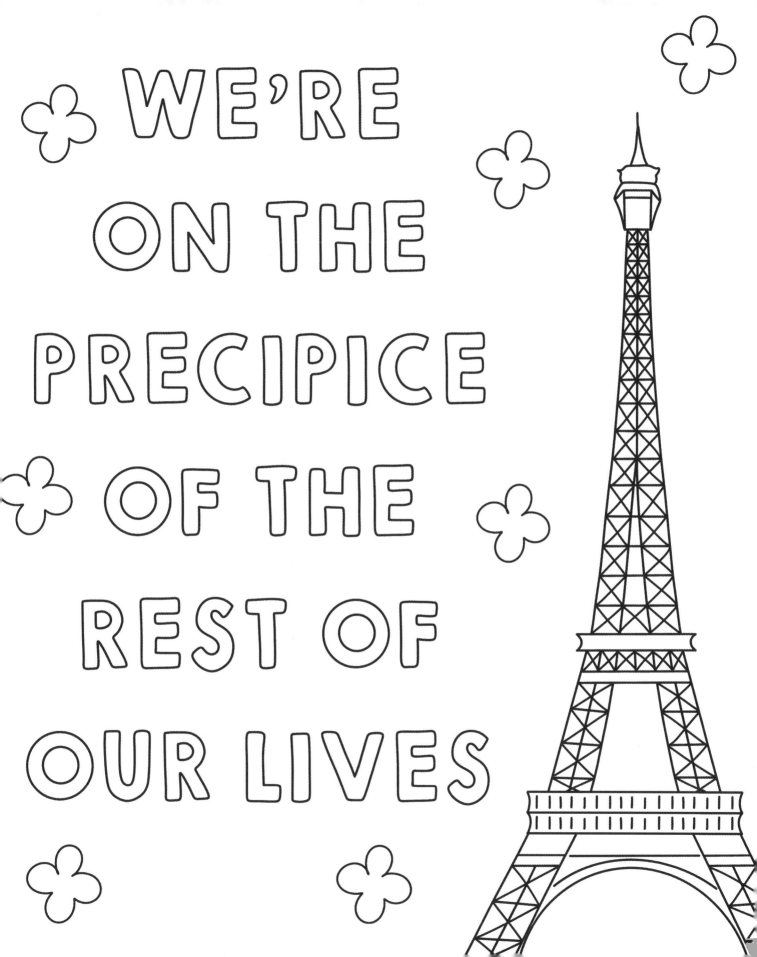

WE'RE ON THE PRECIPICE OF THE REST OF OUR LIVES

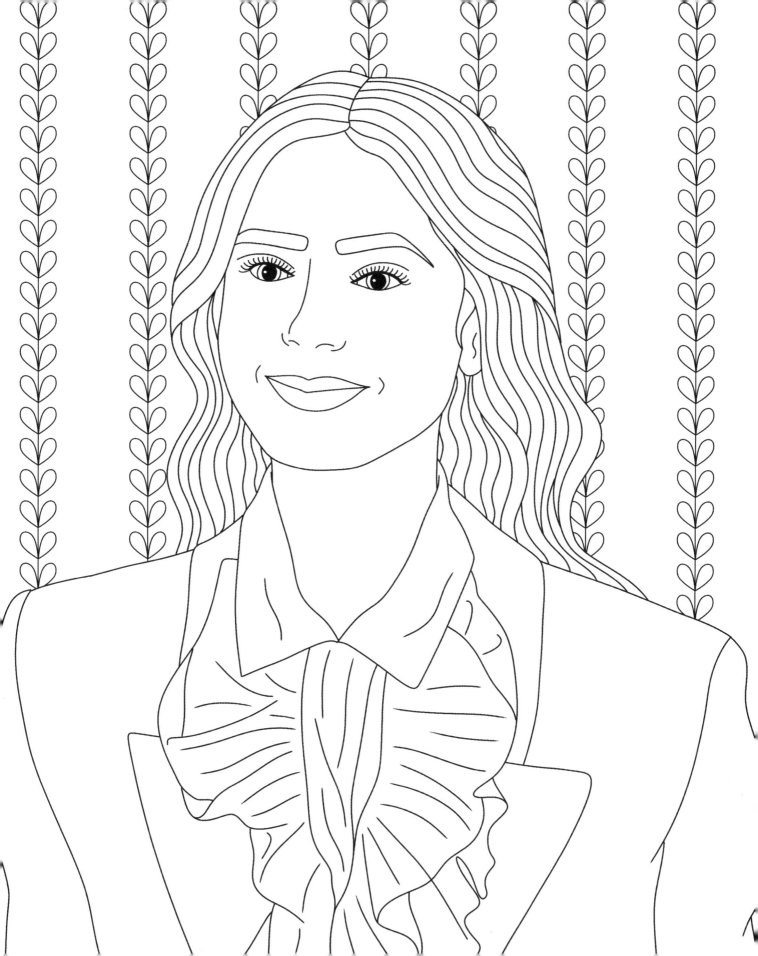

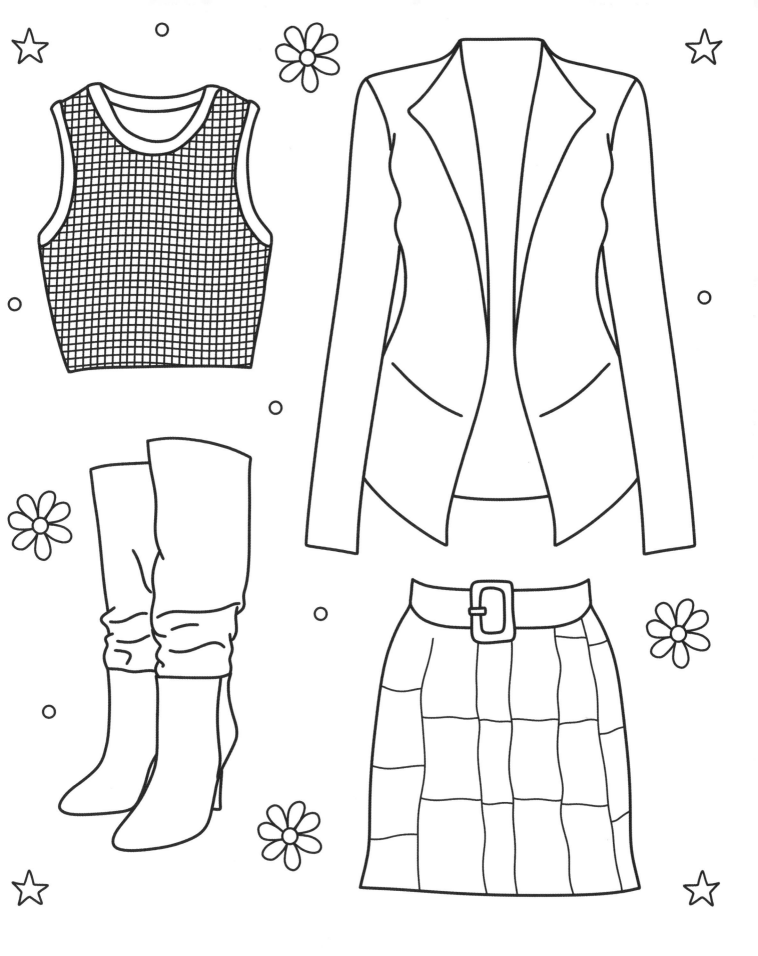

La musique est la langue
des émotions

Inspiring | Educating | Creating | Entertaining

Brimming with creative inspiration, how-to projects, and useful information to enrich your everyday life, quarto.com is a favorite destination for those pursuing their interests and passions.

10 9 8 7 6 5 4 3 2

ISBN: 978-0-7603-7982-0

Printed in USA